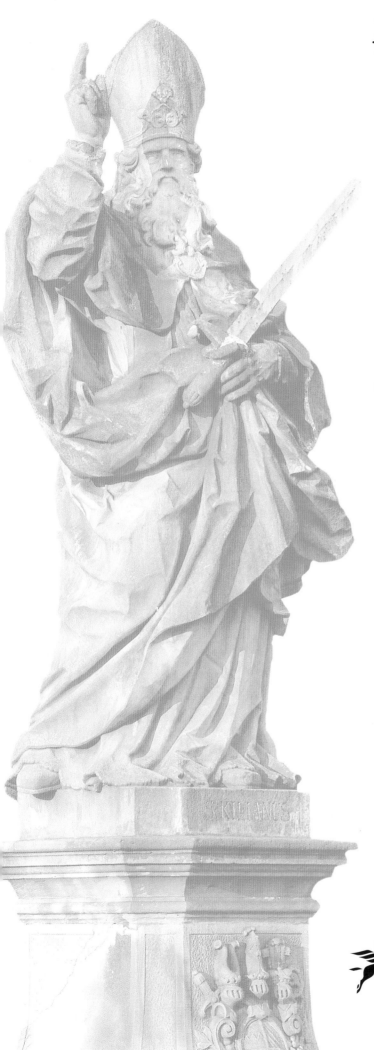

Bayerische Verwaltung
der staatlichen Schlösser,
Gärten und Seen

Bavarian Administration of State Castles,
Palaces, Gardens, and Lakes

Peter O. Krückmann

Residences of the Prince-Bishops in Franconia

The Courts of the Schönborns and of other Prince-Bishops along the River Main

Prestel

Munich · London · New York

CONTENTS

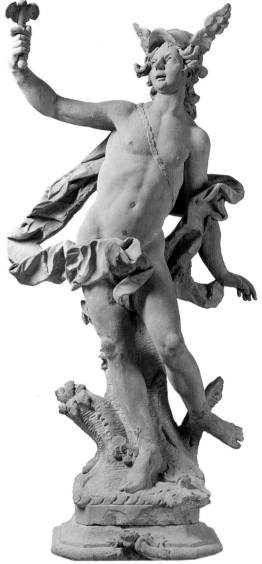

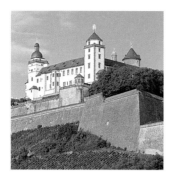
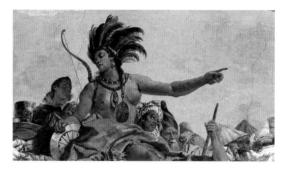

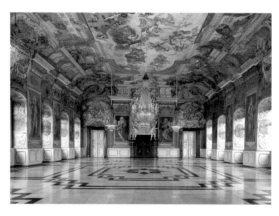

The Prince-Bishops in Franconia

Whoever travels today through Bavaria, Germany's largest state, will soon be impressed by the diversity of its regions. Franconia is different from Old Bavaria, Swabia varies from the Upper Palatinate. Unmistakable characteristics can be detected even within these various regions. One only has to travel sixty kilometres in today's administrative district of Upper Franconia from Bamberg to Bayreuth to gain the sense of entering a different cultural area, or even another country.

The reasons for this exceptional cultural diversity can be found in the independent development of the regions. The Free State of Bavaria, as it is known throughout the world today, is the outcome of political events that took place about two hundred years ago. Between 1796 and 1818, owing to the upheavals caused by the troops of the French Revolution having conquered parts of Franconia, important and previously independent territories were gradually acquired by the Kingdom of Bavaria. These included the Catholic principalities, or *Hochstifte*, Bamberg and Würzburg, the Protestant margravates Ansbach and Bayreuth, various counties, imperial towns and even imperial villages as well as the lands of the Electorate of Mainz on the lower Main around Aschaffenburg. This marked the irreversible end of local territorial traditions, many of which had existed for well over a millennium.

The subject of this book is the north-western part of Bavaria, culturally a relatively uniform region, which is clearly demarcated from the neighbouring areas. It encompasses the three former prince-bishops' residences Aschaffenburg, Würzburg and Bamberg. Among the reigning bishops in the Baroque period, one name recurs repeatedly: the Counts of Schönborn. They determined the fortunes of these lands for approximately one hundred years. This is all the more remarkable because prince-bishops, unlike secular monarchs, did not follow a hereditary line of succession to power, but were elected by the cathedral chapter and here various interests often clashed. Political prestige, tactical skill and an instinct for power resulted in a dynasty of prince-bishops from the Schönborn family so that even in the eighteenth century people spoke of the "Schönborn Period", coining the term still used today to cover an epoch when art flourished in Franconia.

Heading the family tree of Schönborn rulers was Johann Philipp (1605–1673), who was Prince-Bishop of Würzburg, Mainz and Worms. It should be noted that the Mainz office was the highest in status for any church dignitary. Apart from this he was Archchancellor of the Empire, one of the emperor's highest dignitaries. He was succeeded by his nephew Lothar Franz (1655–1729), who became Archbishop of Mainz and Bishop of Bamberg and in the latter position resumed in Baroque style the building of the New Residence, begun before the Thirty Years' War. He also built Pommersfelden Palace. Of his brother's four-

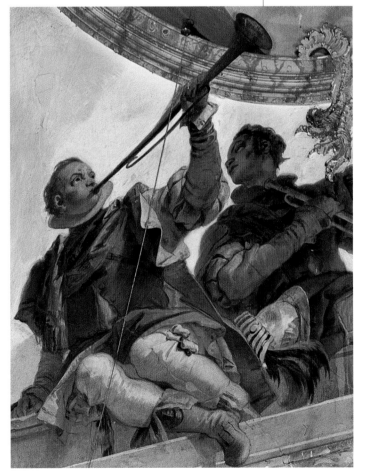

A horn is sounded to herald the investiture of the Würzburg bishop Herold with the dukedom of Franconia by Emperor Frederick Barbarossa: the beginning of a glorious, over 600-year-long era. Detail of a fresco by Giandomenico Tiepolo in the Emperor's Hall of the Würzburg Residence.

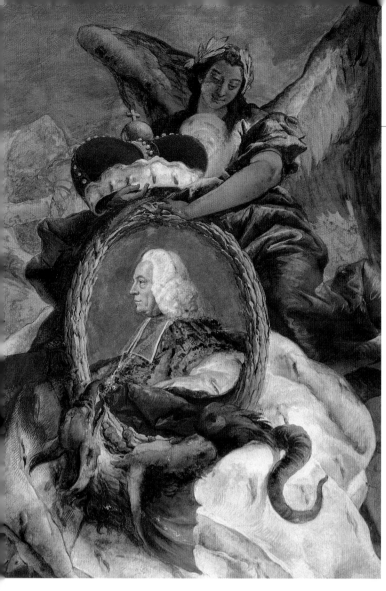

teen children, four of the sons were gradually elected bishops and archbishops of Bamberg, Würzburg, Treves, Speyer and Constance and prince-provost in Ellwangen. Friedrich Carl von Schönborn (1674–1746) was one of these brothers. Even before he was elected bishop, he advanced to become Imperial Vice-Chancellor of the Holy Roman Empire of the German Nation—one of the highest offices in the emperor's political administration. Later as Prince-Bishop of Bamberg and Würzburg he created with the newly started Würzburg Residence the most celebrated Baroque palace in Europe after Versailles. Another brother held the county of Wiesentheid.

About two hundred years after the Würzburg Residence was built, this unique work of architecture fell victim to the Second World War—like Johannisburg Palace in Aschaffenburg. The rebuilding of the seriously damaged Residence and the reconstruction of the exquisite rooms under the direction of the Bavarian Administration of State Castles, Palaces, Gardens and Lakes (Bayerische Verwaltung der staatlichen Schlösser, Gärten und Seen) is one of the great achievements in monument preservation in the post-war period. The other palaces, at Veitshöchheim, Aschaffenburg, Schönbusch and Bamberg, are administered by the same authority. Each year many hundreds of thousands of visitors from all over the world visit these sights that encompass almost all of art's epochs from the Middle Ages to the nineteenth century. Because of its unique importance, the Residence in Würzburg was added by UNESCO to the World Cultural Heritage List. The Old Town of Bamberg has likewise been acknowledged as a World Cultural Heritage Site, including the New Residence there.

The third volume of the regional guides about the sights maintained by the Bavarian Palace Administration seeks to introduce this unique heritage and contribute to historical and artistic understanding.

Marienberg Fortress

Würzburg's beginnings reach back into the darkness of prehistory, when in the Urnfield and Hallstatt Period the first inhabitants settled on the sheltered and fertile banks of the Main. Later, Celts settled in this area and in the sixth century the Franconian-Thuringian dukes claimed the hill, Marienberg. Following the Christianisation of Franconia, Saint Kilian, who is still venerated by wide circles of the population, was martyred in 689 with his companions. His burial chapel, around which a settlement gradually developed, was to become the heart of the city of Würzburg. According to tradition, Duke Hetan II founded a church in 706 on the far side of the Main, on the Marienberg, probably on the site where the pagan ring wall was originally situated. A few years later the church and the entire hill were given to the bishops of Würzburg. With

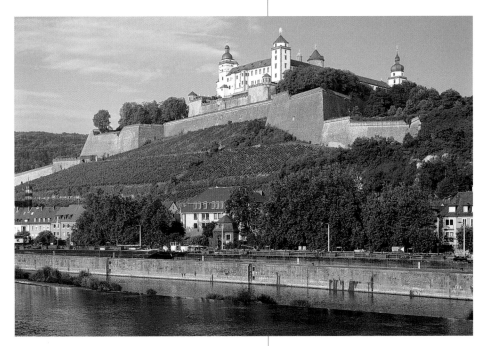

Marienberg Fortress, the original seat of the prince-bishops, stands high above the city of Würzburg, which lies on the opposite bank of the River Main.

these two sites, the future development of the city was traced out for more than a thousand years.

The strong religious character that is still a feature of Würzburg today goes back to the many religious foundations and monasteries that were established from the eleventh century onwards. As the ecclesiastical reputation flourished, the bishops' secular powers also grew. Through the strategic acquisition of several counties and the attainment of jurisdiction over the city, ecclesiastical dignitaries became sovereigns. By 1168 their power had grown to such an extent that Emperor Frederick

In 1937/38 the formal Princes' Garden was reconstructed on a terrace in front of the east wing of the fortress after plans dating from the early eighteenth century.

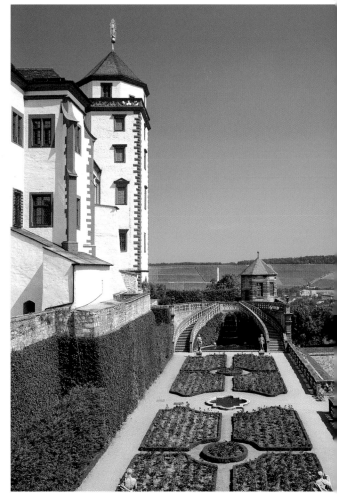

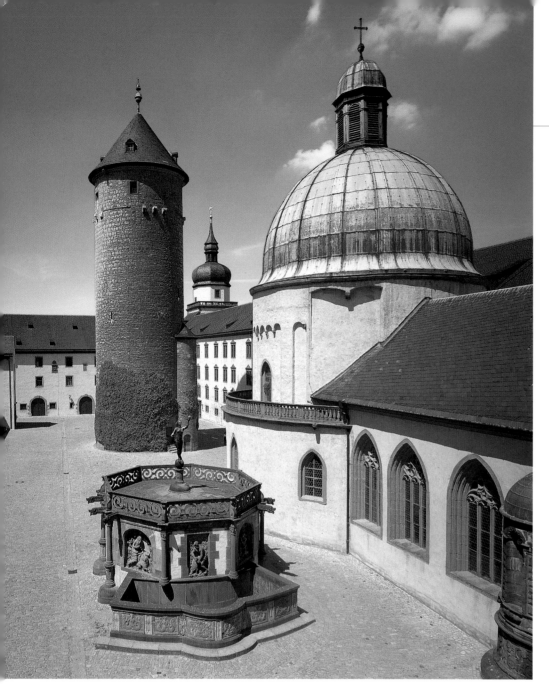

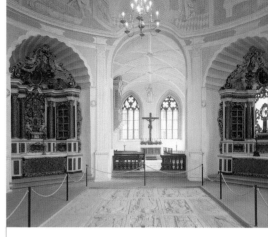

The interior of the Marienkirche was refurbished during the Gothic and early Baroque periods.

The oldest part of the Marienberg Fortress is the 1,000-year-old Marienkirche.

Stretching to the west is an imposing bulwark, parts of which were erected by the Swedish troops that captured the episcopal fortress in 1631.

Barbarossa officially recognised the dukedom of the Franconian bishops. Six hundred years later, Giambattista Tiepolo was to depict this event in his world-famous frescoes in the Würzburg Residence. As in many other towns, the tense relations between the prince-bishops and the self-confident inhabitants of the city caused conflicts. Consequently an alternative to the city residence was sought and the most appropriate site for a new episcopal castle was on the **Marienberg**. That was in the year 1200.

The scale of this first four-winged complex was vast; it roughly corresponded with the **main castle** today. Of this only parts of the keep have been preserved, which were integrated into a later building. At the centre of the castle was the church, **Marienkirche**, which still exists today and looks back on centuries of tradition. Around the year 1000 it attained its characteristic form of a round church, inspired by Italian models. The interior was remodelled at the beginning of the seventeenth century.

After the extension of the fortifications in the fifteenth century, a new epoch began for the fortress after 1600. Fire damage, but above all a new zeitgeist, inspired the important Prince-Bishop Julius Echter von Mespelbrunn to remodel the old castle, transforming it into an imposing palace. Facing the city

Among numerous ecclesiastical works of art, paraments and sculptures are especially well represented in the Fürstenbaumuseum.

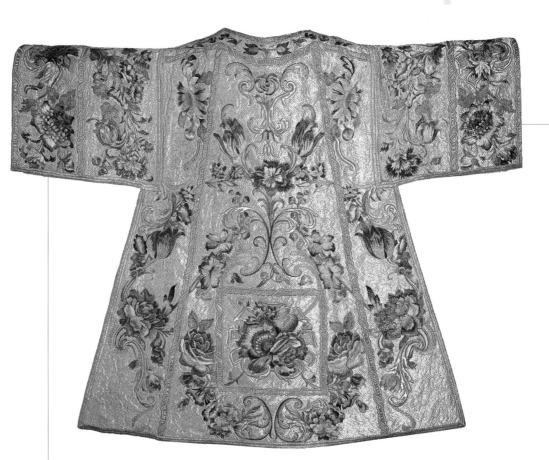

The heart of the Mainfränkisches Museum consists of a world-class collection, which includes works by Tilman Riemenschneider, such as this *Virgin Mourning* from around 1505.

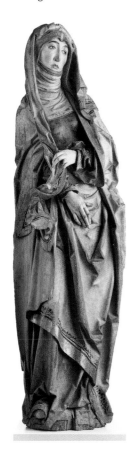

he added a tower, the **Marienturm**, to the north façade as a counterpart to the southern **Sonnenturm**, in keeping with palace architecture of the late Renaissance. Besides the renovation of the north wing, the construction of the western part of the bailey and the bastion, called the **Echterbastei**, also dates back to this prince-bishop. Nothing has survived of the equally ambitious interior decoration. This was lost in the Thirty Years' War, when the Swedish army stormed and plundered the fortress. Some of the objects can still be found in Swedish palaces today.

In the seventeenth and eighteenth centuries the fortifications were extended and the apartments refurbished. After the decision in 1719 to transfer the household to a new city residence, these new furnishings also perished. However the palace retained its function as a fortress for a longer period.

Following the reconstruction after the Second World War, the fortress today houses two museums: the **Fürstenbaumuseum**, with exhibits relating to the history of the city and palace, and the **Mainfränkisches Museum**, a collection of worldwide renown, featuring highlights of centuries of Franconian art. Of unique importance are the sculptures by Tilman Riemenschneider dating from the transition period from late Gothic to Renaissance.

Even if the splendour of the imposing centre of Julius Echter von Mespelbrunn's sovereignty has been lost, the architectural design of the castle and its location, overlooking the Main, can still be appreciated today and this gives the city-scape its characteristic silhouette. Over and above its function as a fortress, the Marienberg was a triumphant symbol, visible from afar, of both the secular and spiritual power of the church in the age of the Counter-Reformation. Even in the middle of the eighteenth century, when the prince-bishops' seat had for a long time been in the new city residence, this concept was vividly expressed in an etching by Giandomenico Tiepolo.

WÜRZBURG RESIDENCE

As early as 1683 the cathedral chapter decided to transfer the household to the city. Johann Philipp von Greiffenclau then commissioned the construction of the small residence, the Little Rennweg Palace (Rennweger Schlösschen), on the opposite edge of the city to the Marienberg, although he never actually lived there. Little is known of its appearance because on his accession in 1719 his successor Johann Philipp Franz von Schönborn decided to demolish this rather unsatisfactory three-winged structure and replace it with a new building. In spite of this, the chosen location could not have been better. Marienberg Fortress, the cathedral and the Little Rennweg Palace were linked in a single visual axis that spanned the entire city. This unmistakably displayed the power relations to all.

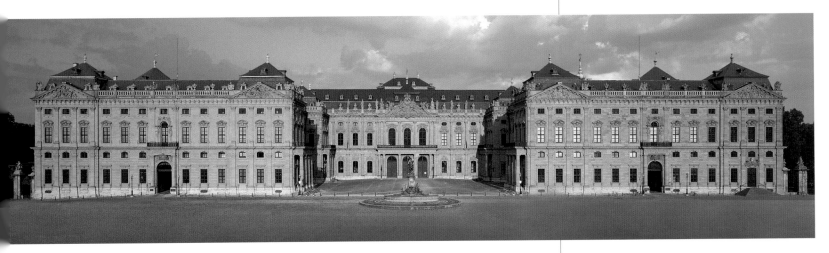

With a typically Baroque turn of phrase, one of the Schönborn counts said that he was seized by a "Bauwurmb" (building mania). It is true that many of the Schönborn counts were obsessed with building, so that the residence project rapidly became a family endeavour. Johann Philipp Franz received advice from all sides, based on the ideas of the most sought-after architects of the day. His younger brother Friedrich Carl, the Imperial Vice-Chancellor in Vienna,

The monumental Residence begun by the Würzburg prince-bishop Johann Philipp Franz von Schönborn reflects the growing need of rulers to display their princely power.

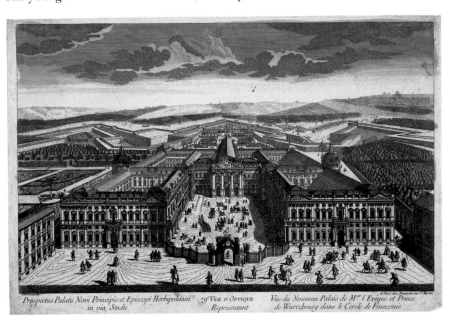

Prospectus Palatii Novi Principis et Episcopi Herbipolitani in via Stadii. 79.e Vue d'Optique Representant. Vüe du Nouveau Palais de M.gr l'Evêque et Prince de Wurtzbourg dans le Cercle de Franconie.

Until 1821 the *cour d'honneur* was separated from the vast forecourt by an elaborate ironwork gates forged by Georg Oegg after a design by Lucas von Hildebrand.

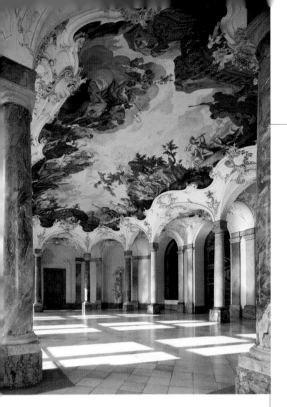

In 1750 Johann Zick painted two frescoes on the ceiling of the Garden Hall, *Feast of the Gods* and *Diana, Goddess of the Hunt*, which allude to the festivities that were held within its walls and the courtly passion for hunting pursued here.

In 1894 the celebrated Munich brass-founder Ferdinand von Miller erected the Franconia Fountain in the forecourt of the Residence.

contributed the suggestions of his architect Johann Lucas von Hildebrand, while his uncle Lothar Franz, who resided in Mainz and Bam-berg, let Maximilian von Welsch have his say. Because the court at Versailles was the undisputed model at this time, the French architects Robert de Cotte and Germain Boffrand were naturally consulted as well. For the Würzburg architects Balthasar Neumann and initially Johann Dientzenhofer, this could not have been an easy situation. The fact that despite this the **Residence** reflects Neumann's unmistakable style and that it is acknowledged as the finest example of Baroque palace architecture in Europe after Versailles, bears witness to the genius of this architect who came from Eger but settled in Würzburg.

The question that comes to mind is how a prince-bishop of a wealthy but comparatively small state could afford a palace, which other potentates could not even dare to dream of. Without a fortunate turn of fate at the right time in the form of an embezzlement scandal, this project would in fact never have been feasible. The court treasurer of the prince's predecessor had managed to set aside vast sums over the years, in ways that were clearly far from correct. Johann Philipp Franz had barely come to power when he confiscated the fortune of the accused, which amounted to the no mean sum of 500,000 florins, worth in today's money about 30 million euro: the rebuilding of the largest German residence could be launched!

In the same way as a secular prince, the prince-bishop's residence was supposed to glorify the sovereign's family. The only problem was that in this

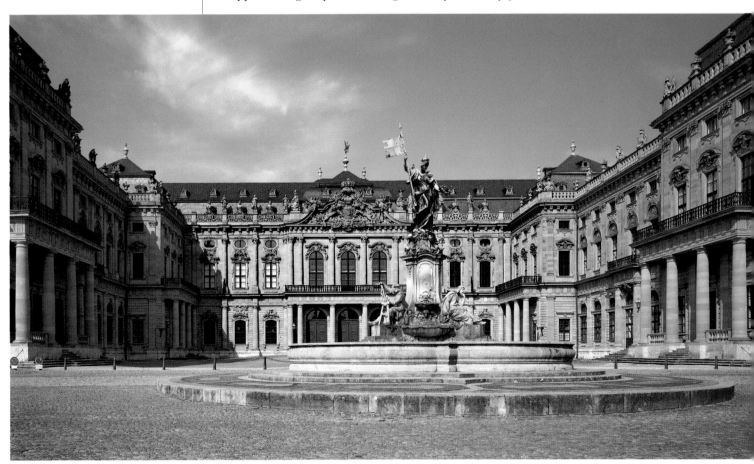

case there was no hereditary line of succession but each new regent was elected from a number of candidates by the cathedral chapter. And here there was a considerable element of uncertainty. Indeed, after the death of Johann Philipp Franz the faction opposed to the Schönborns gained the upper hand in the cathedral chapter and the new prince-bishop was Christoph Franz von Hutten. He had little interest in building the Residence, which is why he funded only the makeshift completion of the shell construction of the north-western tract, which had been erected in the five years up to 1724. Yet Hutten's reign did not last long. Already in 1729 a Schönborn was back on the throne. He managed to complete the building by 1744, two years before he died. The most difficult task

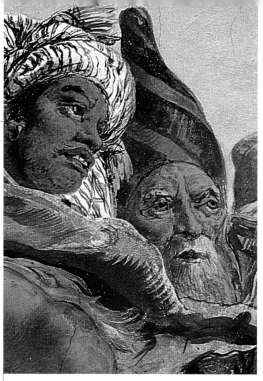

Inhabitants of America as Tiepolo and his contemporaries envisaged them.

The Grand Staircase and ceiling fresco by Giambattista Tiepolo (right), seen from the vestibule (left).

The firmament opens up above the personification of America, with the sun-god Apollo at the centre shown leaving his heavenly abode to mount his sun-chariot.

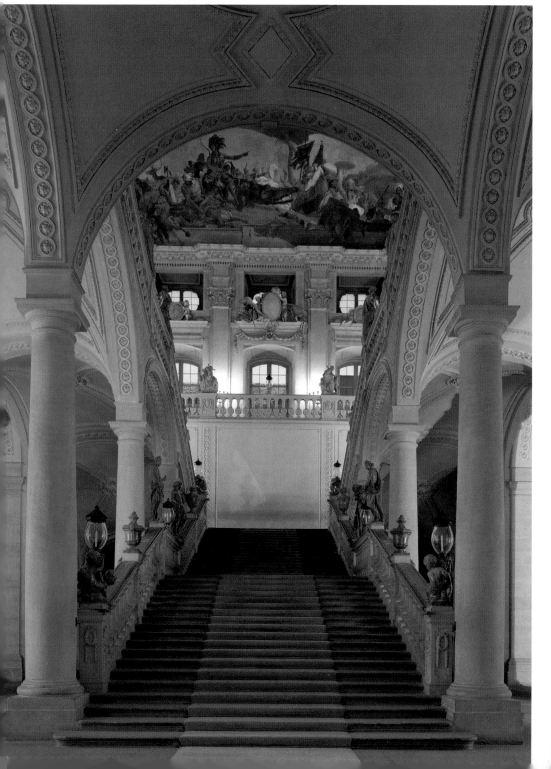

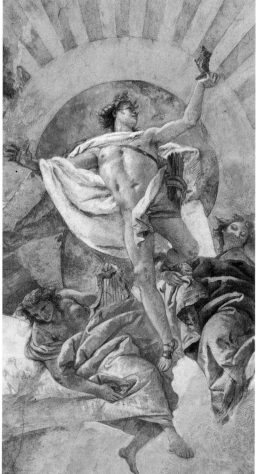

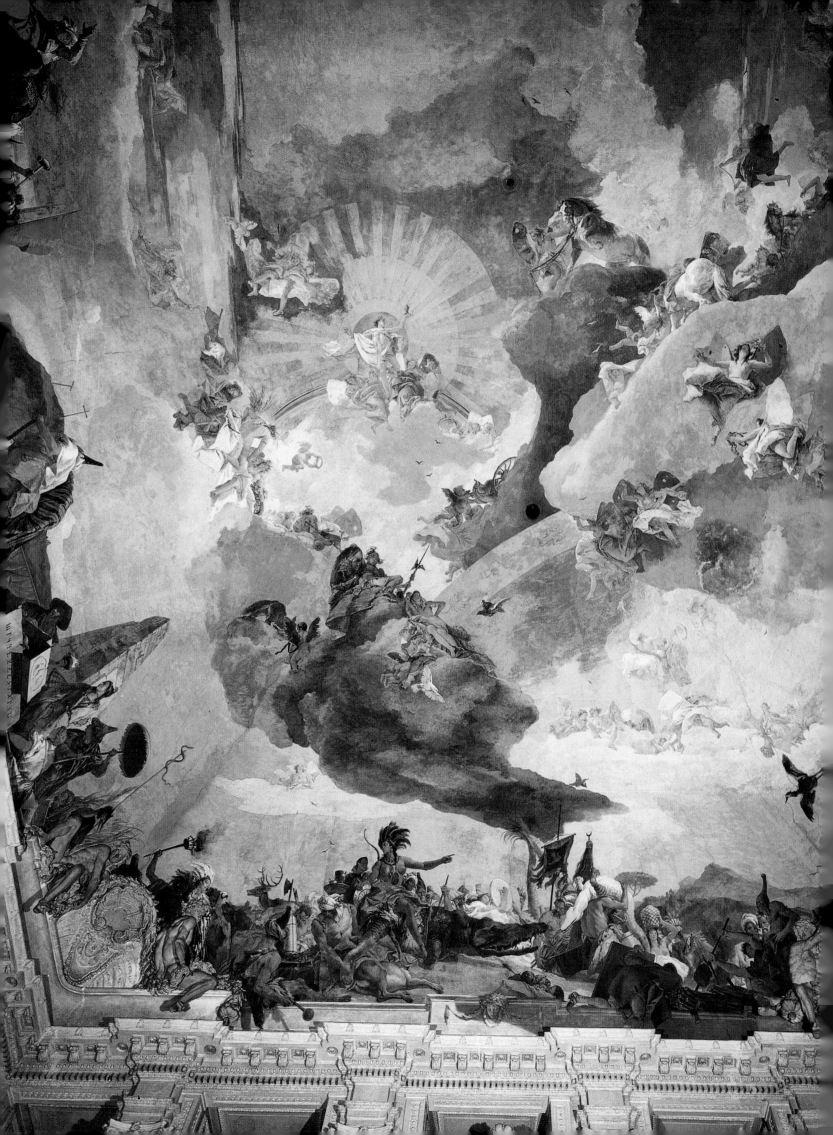

for Balthasar Neumann, who had increasingly taken charge, was in the final phase. This was the vaulting of the vast state apartments: first and foremost the Grand Staircase (Treppenhaus), but also the White Hall (Weisser Saal) and the Emperor's Hall (Kaisersaal).

The following anecdote is known. In response to the qualms about whether the wide, flat vault over the staircase was sufficiently stable, Neumann agreed to fire off a mortar at it. But this silenced the sceptics, as their fears for the building outweighed their doubts, so the architect could complete the vaulting of the ceiling without pillars. This architectural stroke of genius begged for a congenial frescoist who had the ability to create here one of the largest paintings that to date had ever been realised.

But before it was to reach this stage, four more years were to pass. In the same way as in the 1720s, a prince-bishop succeeded who was not the least bit interested in spending even a single florin on completing the Residence. Count Anselm Franz von Ingelheim was much more preoccupied with alchemy and making gold, a pursuit that suited his avaricious nature. After Ingelheim's early death in 1749, a Schönborn did not succeed to the prince-bishop's throne. Yet Carl Philipp von Greiffenclau soon turned out to be a like-minded personality who was equally interested in art. It is thanks to him that this magnificent palace was decorated by a painter who matched its brilliance: the Venetian artist Giambattista Tiepolo! The challenge of painting *one* fresco on surfaces that exceeded the scope of a single gaze was mastered by Tiepolo with bravura, as we shall soon see. It is as if he himself designed the architecture in this way and no other in order to paint here the most important ceiling painting of the eighteenth century. Indeed it would seem that the sole purpose of Greiffenclau's office was to bring Tiepolo to the Main. Less than two years after Tiepolo completed his work, this prince-bishop with a vision for the grand style died, in 1755. In order to appraise what was created here in Würzburg we shall take a tour of the state apartments in the palace, experiencing it just as one of the prince-bishop's guests might have done some two hundred and fifty years ago.

The tour begins a long way in front of the Residence. If we approach the palace through the streets that lead to it from the cathedral, we arrive unexpectedly in the wide forecourt—a change of scene that could hardly be more striking. As we draw nearer to the broad, monumental palace, situated on a slightly higher level, our gaze closes in until we have entered the *cour d'honneur* and are approaching the central portal. It must have been like being on stage, where the members of the court and musicians stood on the surrounding balconies to survey and greet arriving guests.

On entering the palace, the first impression could be disappointing as there is no large, light hall but a rather cramped and dimly lit **vestibule**. But this is part of the highly skilful architectural "staging". The vestibule is only a transition point in the ceremonial passage. This is followed by the true highlight, the walk up the **stairs**, where every step reveals more of Tiepolo's fresco depicting the four continents.

top: Surrounded by her entourage is the personification of the continent of America, an exotically clad Native American shown straddling an alligator.

Tiepolo portrayed in his staircase fresco many artists who were involved in the completion of the Residence, including Balthasar Neumann, its inspired architect.

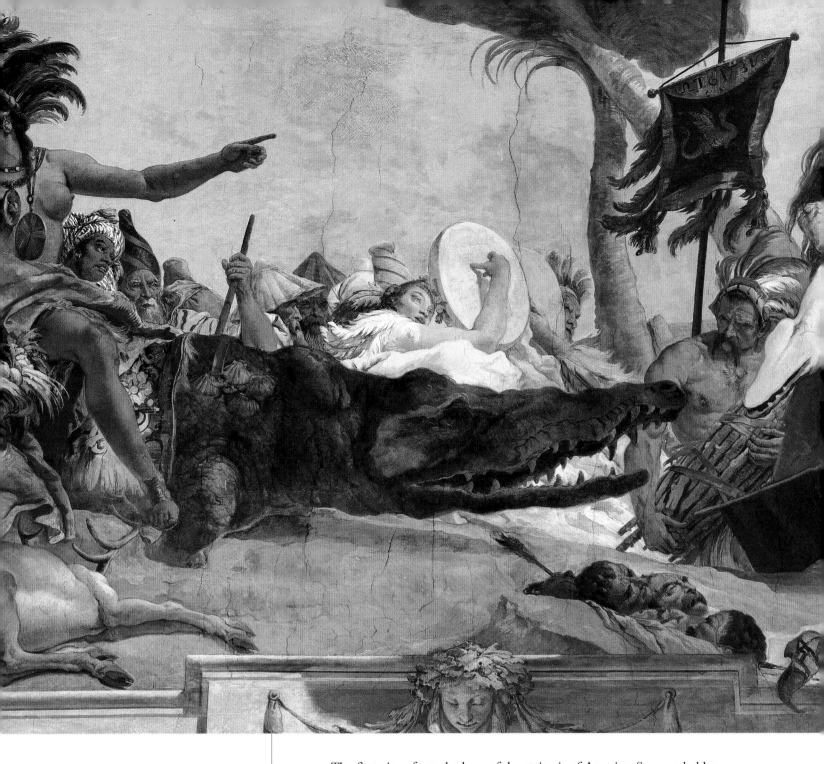

The first view, from the base of the stairs, is of America. Surrounded by her motley entourage, the personification of this part of the world rides on an alligator towards the right and at the same time points the way to the visitor. As we go up the stairs the fresco opens up more and more at the top. Clouds that become increasingly lighter soar upwards until the sun-god Apollo appears. He has just left his heavenly abode to start his daily journey in the sun-chariot across the firmament. The further up we proceed, the more we can see figures from the other parts of the world on the sides above the balustrades—on the left Asia and on the right Africa. It almost appears as if these strangers belong to the court, awaiting those walking up the stairs much like in the *cour d'honneur* of the palace.

Following the outstretched arm of the princess of America, we turn to the right on the landing. We briefly lose sight of the fresco when halfway up we turn to walk up the second flight of stairs. This is again a moment when the scenery changes. The southern narrow side of the ceiling fresco is now presented to us

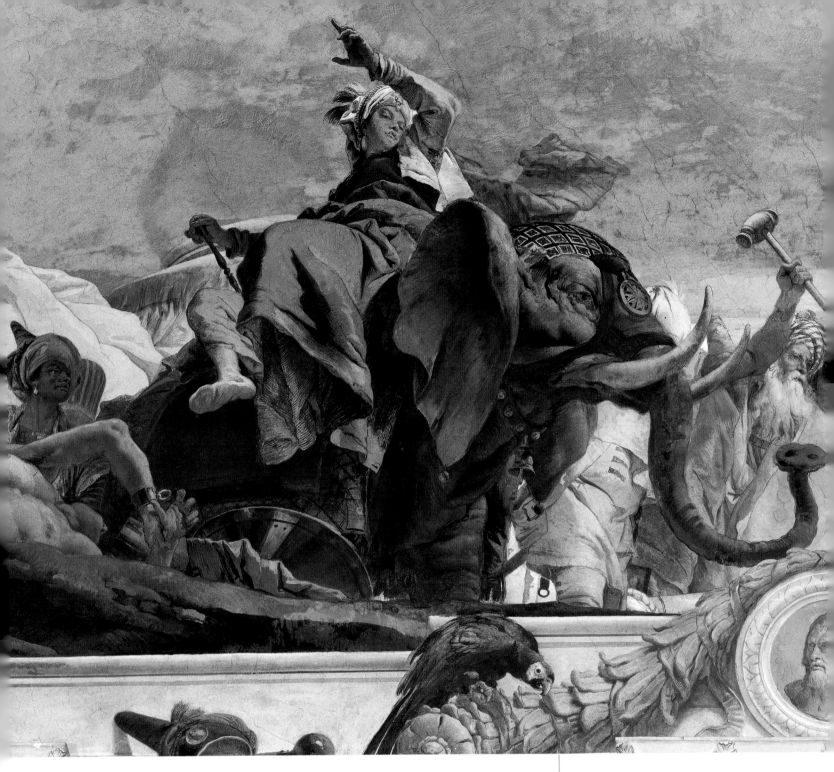

and we are gazing at the personification of Europe. In the centre she is enthroned on a tall base. Her right arm rests lightly on the neck of a bull—the animal disguise adopted by Zeus to abduct her. Representatives of the various arts surround her: on the left a female allegorical figure of Painting, on the right musicians. Standing further to the right is a man wearing a wide cloak. He is the stucco-worker Antonio Bossi, whom Tiepolo has portrayed to represent Sculpture. In front of the group of musicians, Balthasar Neumann is resting on a cannon above the cornice and personifies architecture. The cannon does not allude to his suggestion to check the statics of the staircase but to his military rank as an artillerist. Tiepolo was a close friend of both artists during his years in Würzburg. The painter has also depicted himself. On the far left he peers out from behind stuccowork by Bossi with his son, Giandomenico, who was also a painter and helped his father on many occasions. Floating above it all and borne by genii of glory is the medallion of the patron, Prince-Bishop Greiffenclau.

14

Giambattista Tiepolo's portrayal of himself together with his son, Giandomenico, in the south-east corner of the staircase fresco.

The allegorical figure of Asia is shown as a proud queen riding an elephant, albeit of African origin, past her subjects, with a sceptre in her right hand.

In keeping with contemporary notions, the figure of Africa was depicted as a Moorish queen sitting on a dromedary, while a page kneeling before her burns incense as a gesture of homage.

So what does the painting mean? Actually this can be easily deduced from the composition. In the same way that we proceed from the earthly part of the dim vestibule up the stairs to the light, almost celestial spheres of the prince, the continents likewise form a cultural "ladder" that starts with the still primitive America, populated by cannibals, through Africa and Asia to culminate in Europe, which according to the ideas of the time represented the pinnacle of humanity. Strictly speaking it was of course Würzburg that could claim civilisation's highest echelon because of the good rule of the prince-bishop, whose image has therefore been elevated into heavenly transfiguration. This type of self-glorification was not unusual in the age of absolutism. And of course this message had to exist at the beginning of the reign.

If we walk further we come to the **White Hall,** where the walls and ceiling are decorated solely with elaborate stuccowork by Antonio Bossi as an artistic contrast to the Grand Staircase. This was the room for the bishop's bodyguards.

If we turn to the left, the doors open up to the **Emperor's Hall**. The tremendous impact of this hall is like a clap of cymbals. One enters and stands overwhelmed by the splendour—a completely different reaction from that inspired by the staircase, where the dynamics of the architecture and painting ceremoniously draw one upwards. The reddish tone of the stucco marble, which

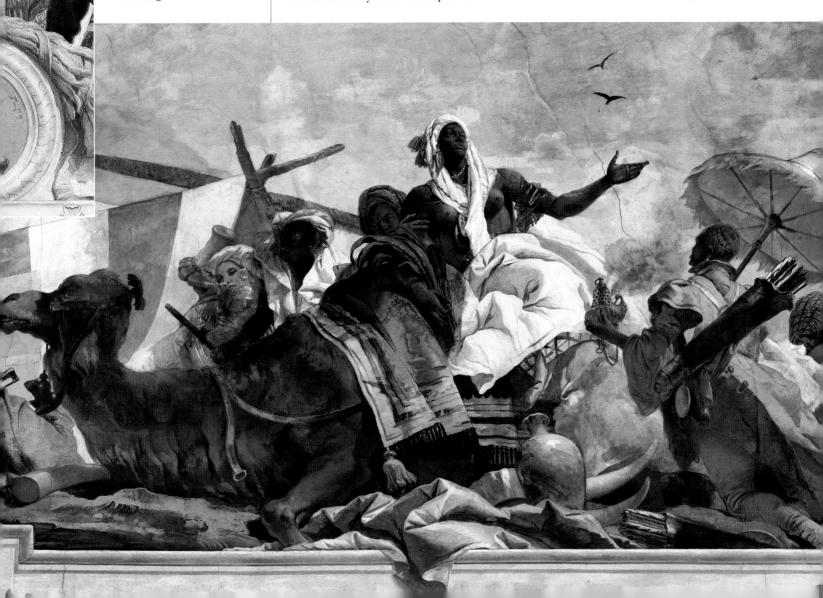

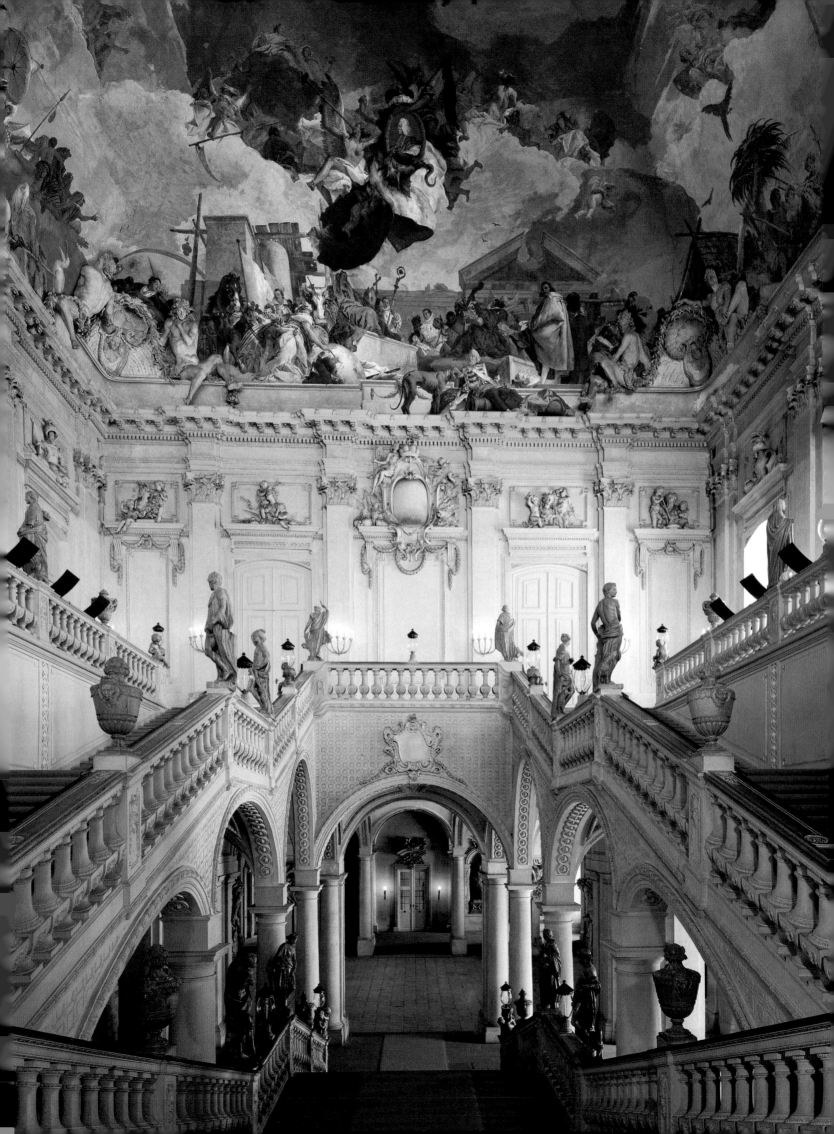

left: The landing of the monumental Grand Staircase affords a fine view of the personification of Europe and a portrait of the builder of the Residence, Prince-Bishop Greiffenclau.

right: The stuccowork in the White Hall, a communicating room between the Grand Staircase and the Emperor's Hall, was executed in 1744/45 by Antonio Bossi.

A page in the marriage fresco.

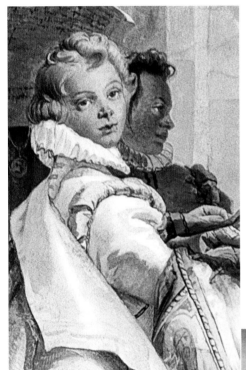

has been used in abundance, gives the hall a majestic appearance and alludes to the imperial purple. But this is something that we register only in passing, as our gaze is drawn upwards to the ceiling, where Tiepolo has painted another fresco. This shows Apollo, who is hurtling out over the edge of a cloud with his sun-steeds. The lady in white is the personification of Burgundy, whom the sun-god is leading to the allegory of the empire, sitting enthroned on the left. To the left of the throne a man is holding the Franconian flag aloft. That which has been depicted allegorically here has a real historical background. In 1156 Emperor Frederick Barbarossa married Beatrice of Burgundy in Würzburg. This can be seen in the fresco over the right narrow side of the Emperor's Hall. That the Emperor was married by the Bishop of Würzburg was always regarded on the Main as a sign of their close alliance. The culmination of this bond of trust was when the Emperor invested Bishop Herold with the dukedom of Franconia, not long after the wedding, in 1168. This can be seen in the fresco on the left side. The Bishop, who kneels before the Emperor here, has Greiffenclau's facial fea-

right: The ceremonial suite of rooms culminates in the lavishly adorned Emperor's Hall.

following pages:
The fresco on the north wall of the Emperor's Hall, which was signed by Giambattista Tiepolo in 1752, depicts the investiture of the Würzburg bishop Herold as Duke of Franconia by Emperor Frederick Barbarossa.

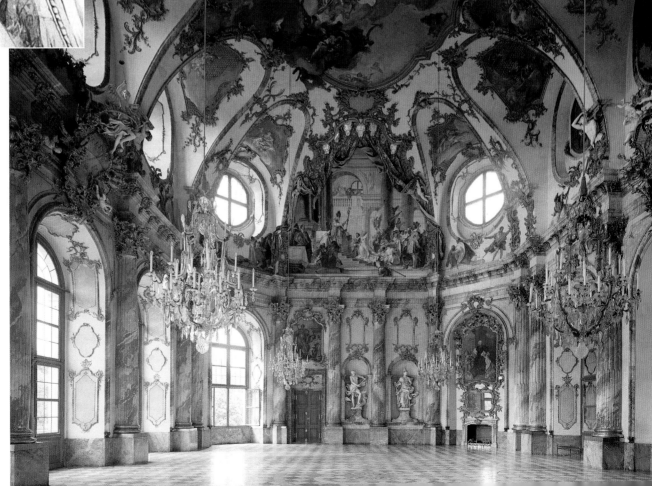

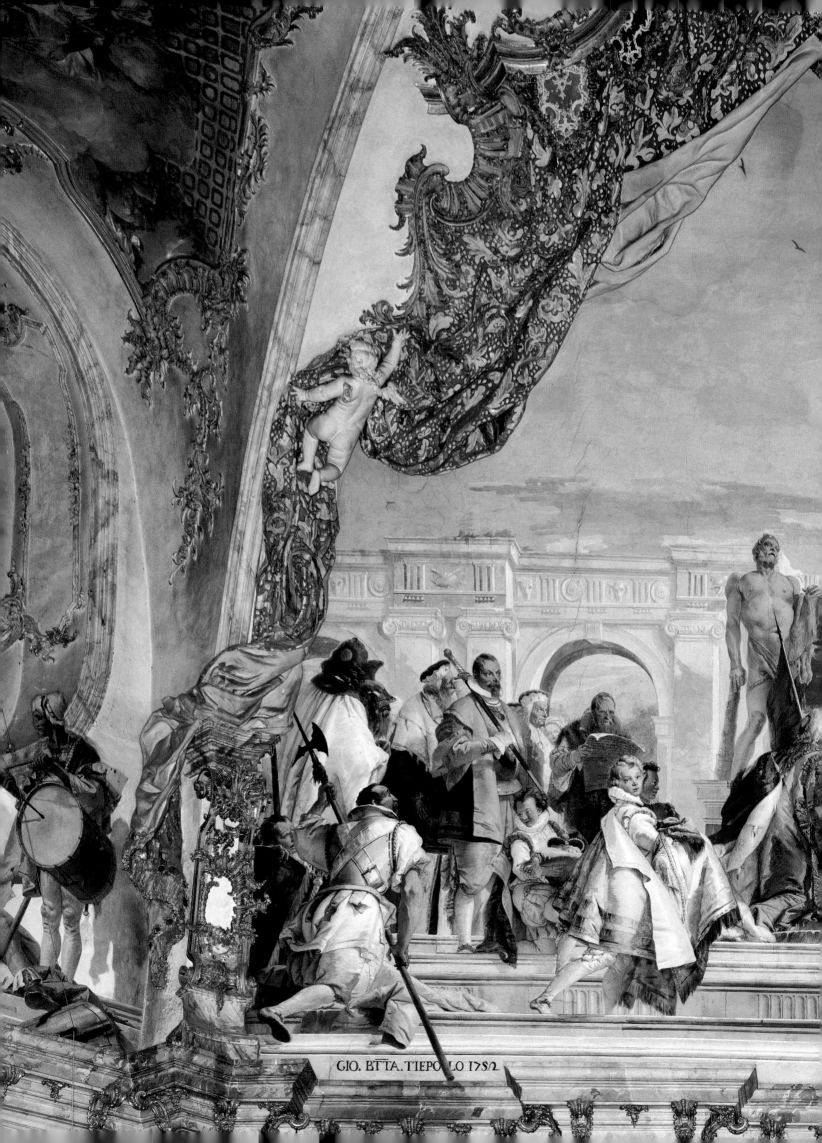

GIO. BTTA. TIEPOLO 1752

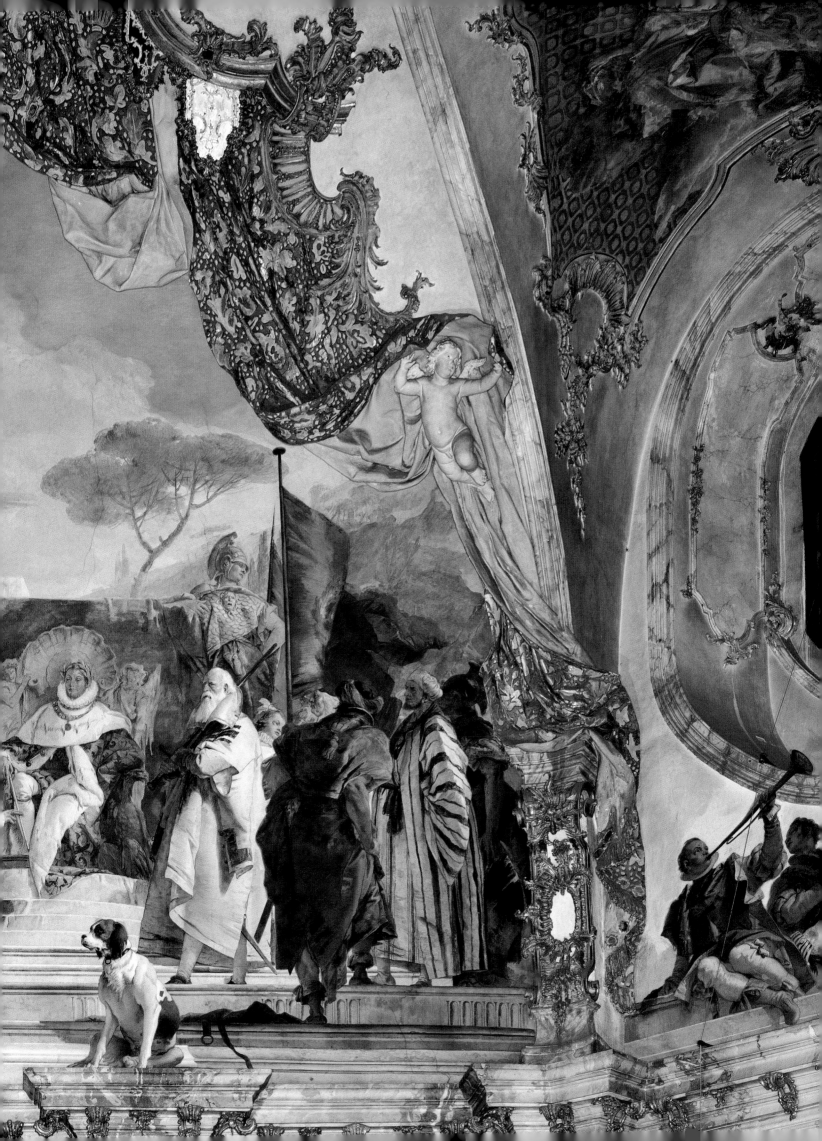

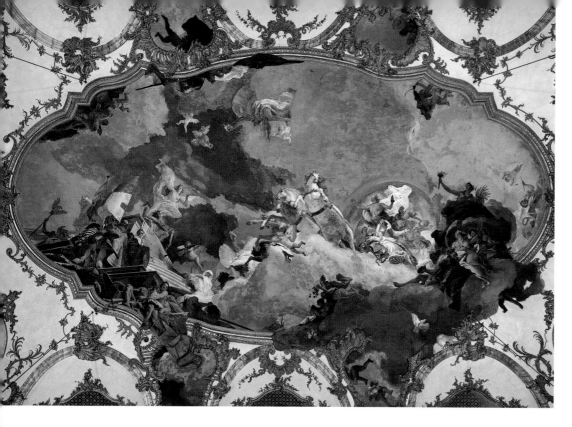

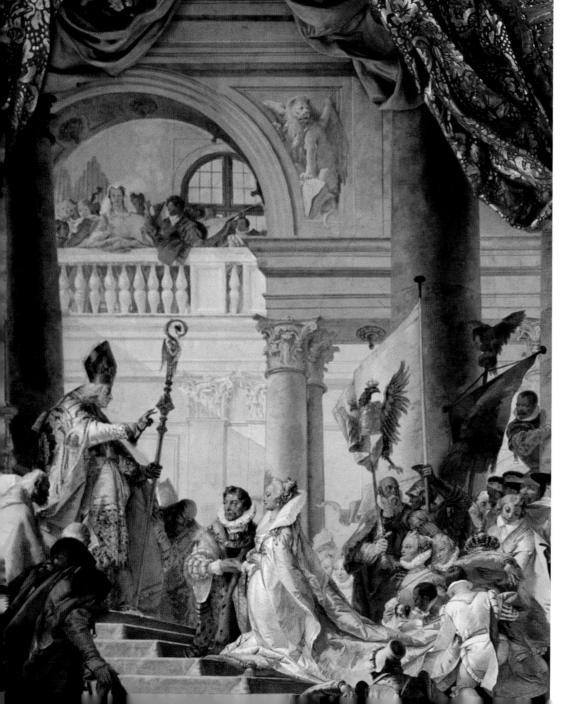

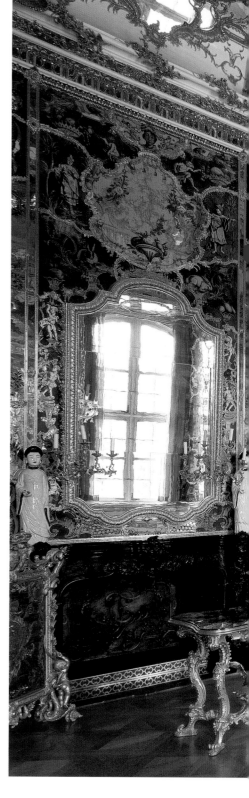

top and bottom left:
Whereas the ceiling fresco is an allegorical depiction of Apollo conducting Frederick Barbarossa's bride, Beatrice of Burgundy, to the *Genius imperii*, the fresco on the south wall portrays the actual marriage of the emperor and Beatrice in Würzburg.

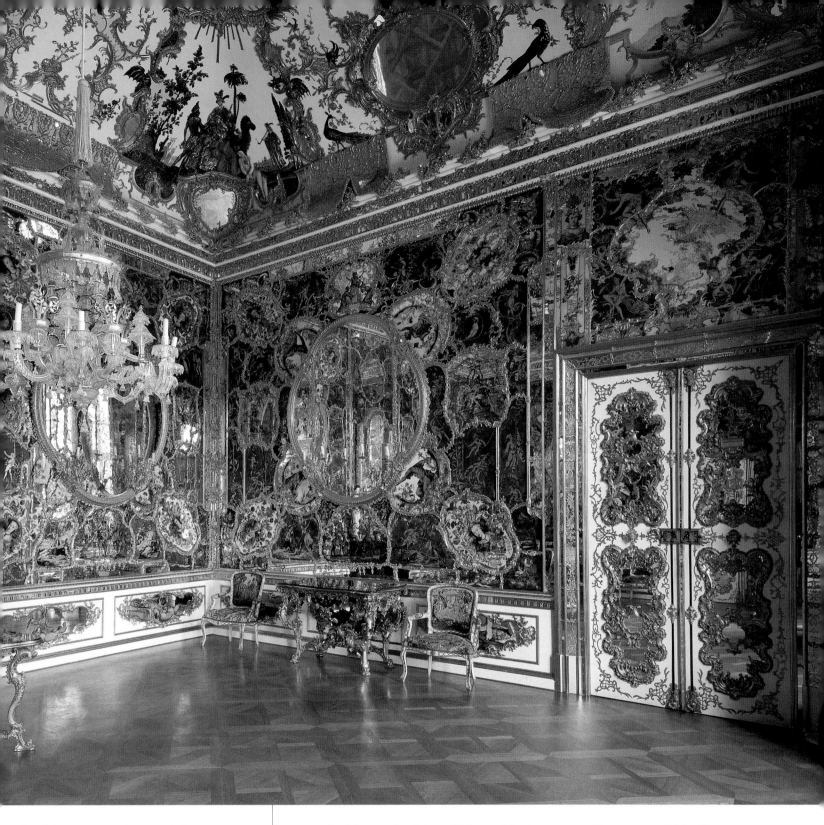

One of the most impressive rooms in the Würzburg Residence is the Cabinet of Mirrors, which, after being destroyed in the Second World War, was painstakingly reconstructed.

tures. In this way the Prince-Bishop wished to express his support of this alliance. In the dramatic times when the borders of Europe were being realigned as a result of the War of the Austrian Succession (1740–48) and the Silesian Wars (1740–45), the latter started by Frederick II of Prussia, a declaration of loyalty to the imperial house had a very topical background. What at first glance is an intoxicating feast for the eyes in paint is revealed at another level as having a concrete political message.

To the right and left of the Emperor's Hall, two luxuriously appointed apartments stretch out over a length of one hundred and sixty metres facing the palace park. These were the **Emperor's Apartments**, which he used when he visited. Of course this did not stop the bishop from using these for his own ceremonial purposes. The highlight of the southern tract is the **Cabinet of Mirrors**,

The *sopraporta* paintings were executed by such celebrated artists as the Venetian Antonio Pellegrini.

or Spiegelkabinett. Destroyed in the Second World War, it was not reconstructed until 1979–87. The walls are entirely covered with mirrors and glass decorated in the painstaking *églomisé* technique with Chinese scenes. The ceiling, which is set with more mirrors, was stuccoed by Antonio Bossi.

The ultimate state room in the north tract of the Emperor's Apartments is the **Green-lacquered Room** (Grünlackiertes Zimmer), where Würzburg Rococo can be appreciated in its more tranquil, late form. Gilded ornaments stand out splendidly from the shimmering green background, which is painted with putti and flowers.

If you do not know where the **Court Chapel** is situated, it is difficult to find the entrance. There is no hint of a chapel anywhere inside the Residence,

Owing to the *commedia dell'arte* and Venetian carnival scenes depicted in the bedroom tapestries in the south tract of the Emperor's Apartments, this room is also called the Venetian Room.

As in many palaces the Würzburg Residence harbours a Napoleon Room, where the French emperor spent the night on a number of occasions.

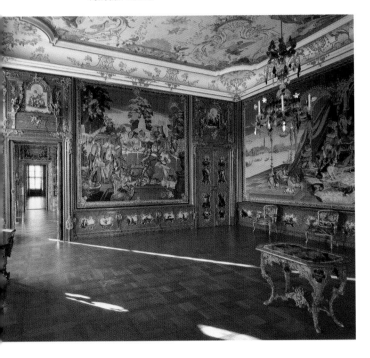

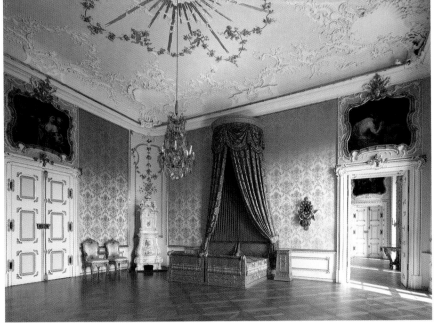

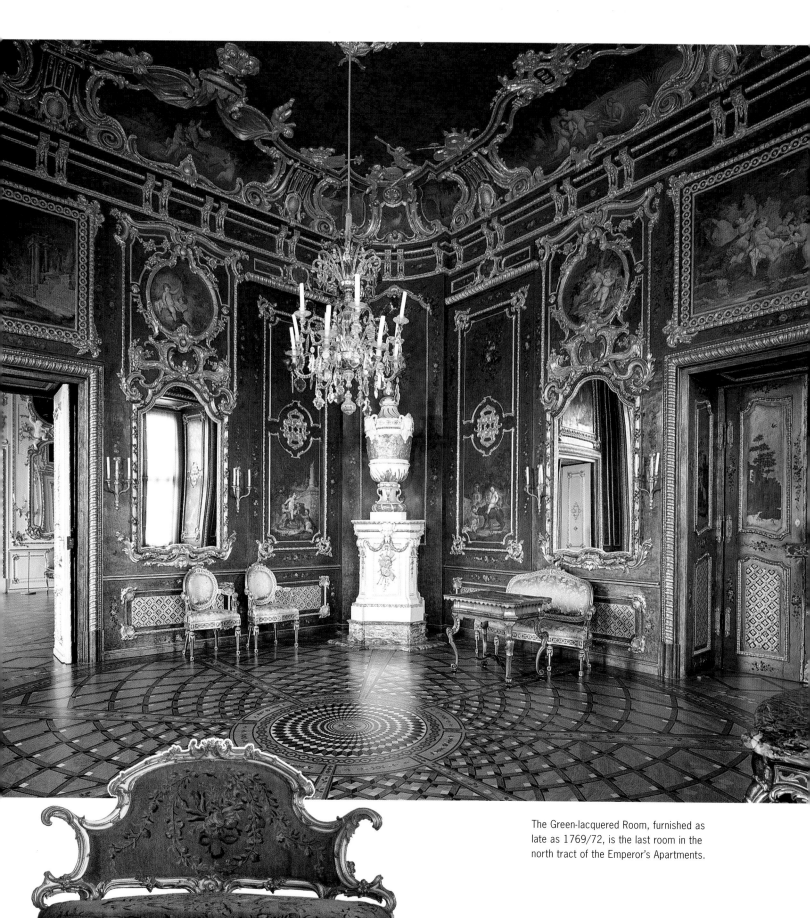

The Green-lacquered Room, furnished as late as 1769/72, is the last room in the north tract of the Emperor's Apartments.

A fine example of the fanciful forms of Würzburg Rococo is a settee designed by Johann Köhler in 1764.

23

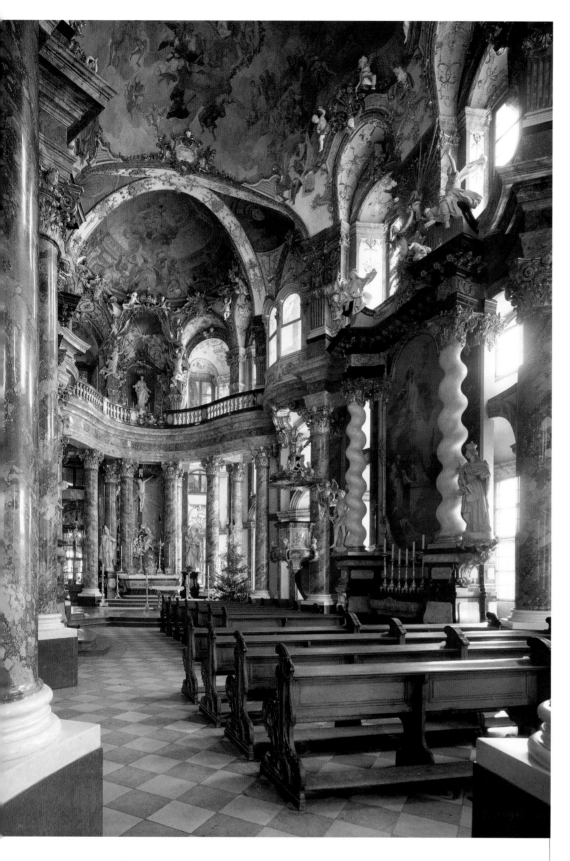

With his two-storey Court Chapel Balthasar Neumann created an interior whose architectonic refinement is virtually unparalleled.

Tiepolo executed the paintings in the side altarpieces, *The Assumption of the Virgin* and *The Fall of the Rebel Angels*, in the winter of 1751/52, when he was forced to interrupt his work on the frescoes owing to the cold.

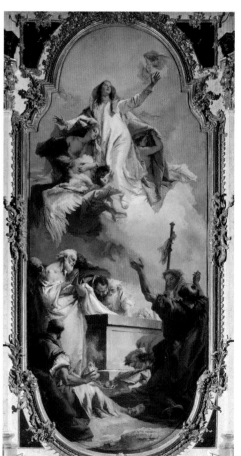

apart from the Christian depictions above the portal on the right wing pavilion of the façade. But once you step through the tall oak doors, you find yourself in one of the most ingeniously devised architectural creations from the time of transition from Baroque to Rococo.

The exquisite design of the room is best revealed by looking at the ceiling. By focusing on the unusual course of the transverse arches that structure the vaulting visually, you will deduce that the ground plan is composed of three ovals. One elongated oval in the centre is intersected at each end by two smaller, crosswise ovals. Together with the multitude of pillars and the light that

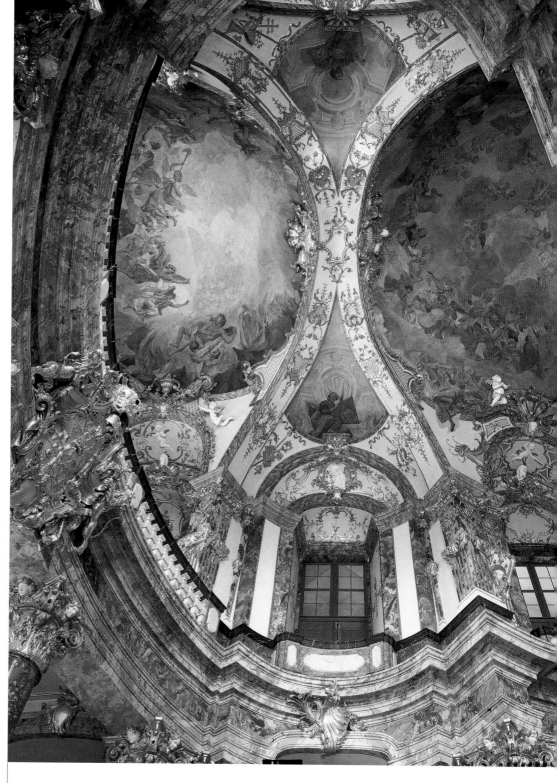

A detail of the Court Chapel's ceiling reveals its complex construction.

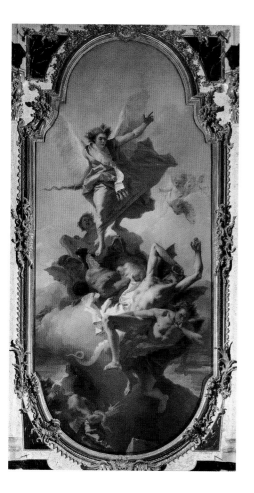

floods in from the concealed south windows at the side, the impression created by the walls and ceiling is not one of solidity but of transparency and immateriality. This creates a completely different notion of architecture's potential. This chapel can no longer be experienced as a sheltering earthly space. To do it justice we must regard it as an image of heaven. The architect of this unique achievement was again Balthasar Neumann.

The furnishings and decoration with frescoes, stuccowork, figures and carvings are all of high quality but the two paintings on the side altarpieces stand out from it all, *The Assumption of the Virgin* and *The Fall of the Rebel Angels.*

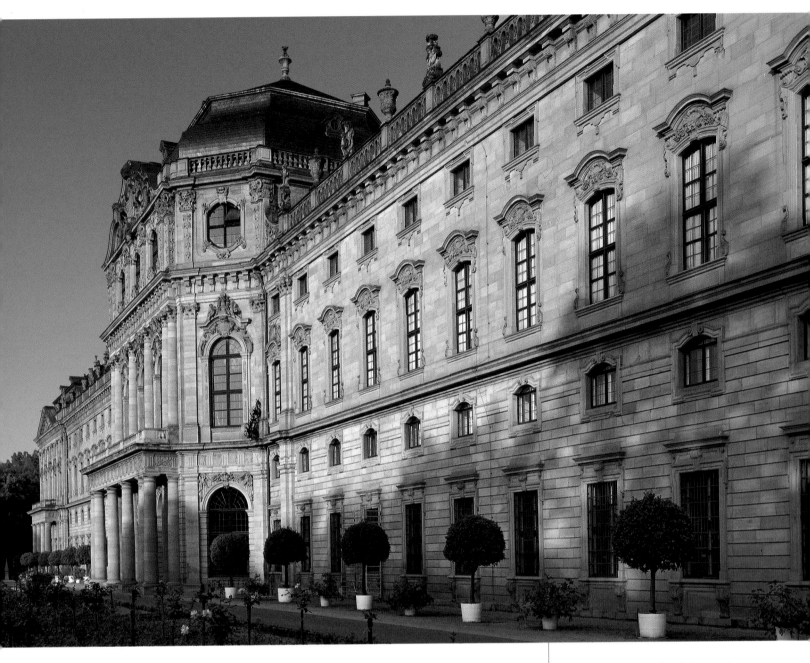

The 165-meter-long façade is accentuated by the middle section, behind which lie the Emperor's Apartments.

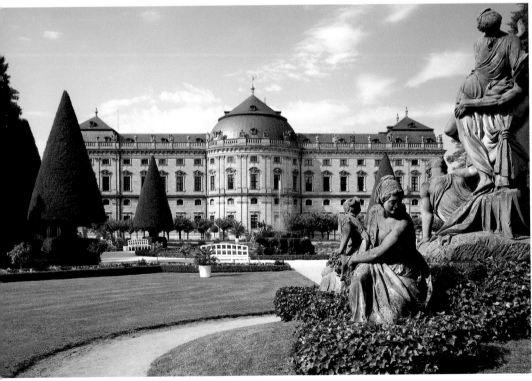

The south façade impresses with its monumental aspect.

Unlike in the original plan of the court garden, which was to be laid out within a series of ramparts, as can be seen in this historic engraving, the Baroque planting was later simplified.

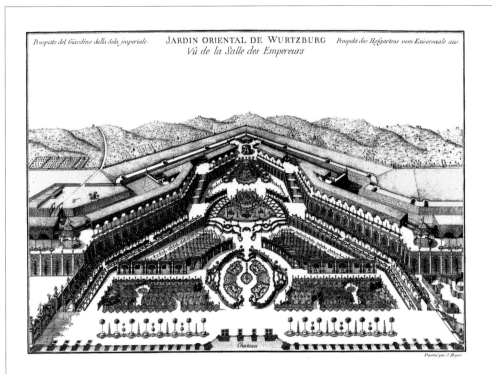

Tiepolo executed these in the winter of 1751/52, as work with the wet fresco paints had to be interrupted because of the cold.

If you visit the Würzburg Residence today it is hard to envisage the devastating damage caused by the bombing in 1945. Decades of effort mean that

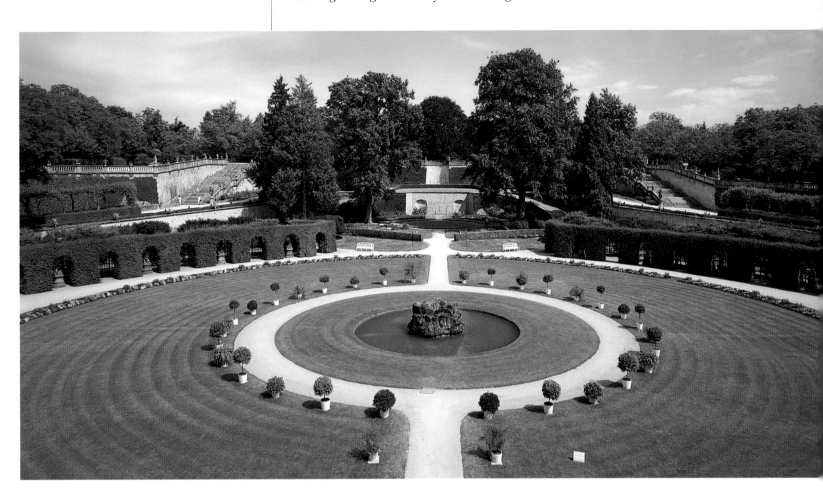

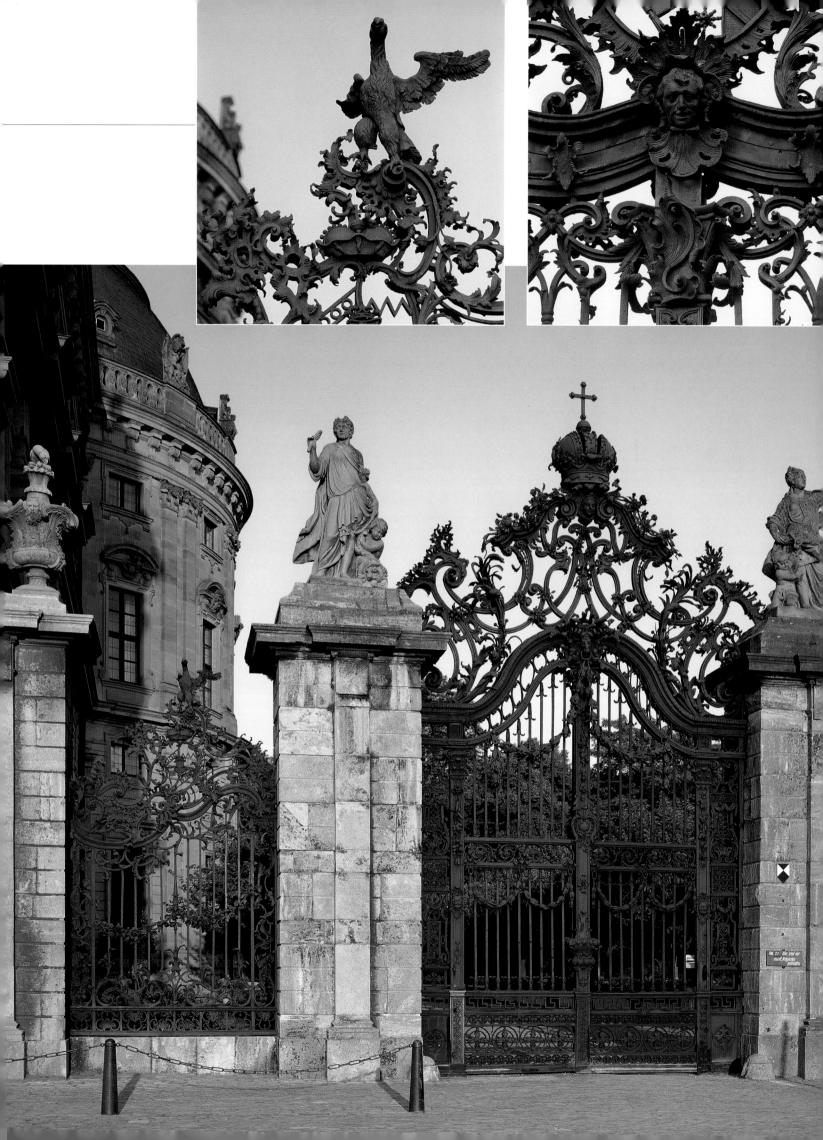

the Residence, as one of the most important examples of palace architecture, has largely been restored to its former glory today. However, not all the historic rooms have been reconstructed. Space has been made for the largest university collection on the continent, the **Martin von Wagner Museum**. On display here are paintings from the sixteenth to the twentieth century as well as archaeological finds from Egypt, Greece and Rome.

The unusual form of the **court garden** that stretches out to the east and south of the palace was shaped by the bastions of the city wall that restricted the available area. This is not a garden of sprawling parterres with canals and avenues, but behind the palace there is a delightful arrangement of graduated terraces that resemble a garden theatre. The garden extends further only in front of the south façade. According to the season an ever-changing array of flowers borders the lawns, in typical eighteenth-century style.

This parterre is located in the large, south section of the court garden, which is adjoined by a landscape garden, a kitchen garden and a cabinet of lindens.

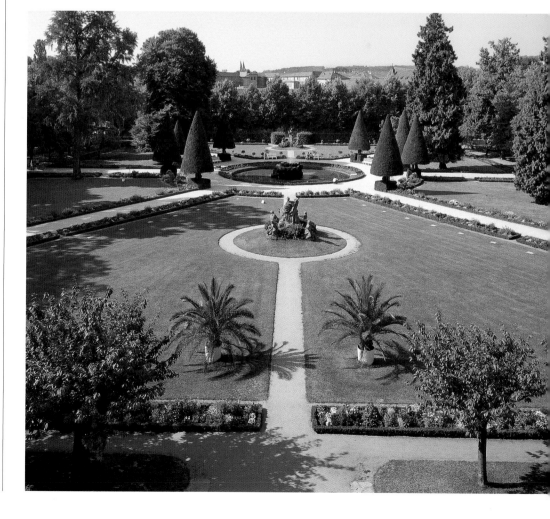

VEITSHÖCHHEIM

Those who have visited the Residence in Würzburg will soon notice that everything is different in Veitshöchheim, although some of the patrons were the same. It is not only that the palace is much smaller, the approach is also very different. There is not an imposing forecourt with the building rising up proudly at the centre. On the contrary, you have to walk through a secluded avenue before arriving at a terrace on which the palace has been constructed. If you look at the ground plan of the complex, the building has been transferred from the centre to the outer edge. The main feature is not the palace but the ornate **Rococo garden** that extends to the south behind a tall wall. What is proudly presented as "the navel of the world" in Würzburg is closed off from the outside here and virtually inaccessible.

The reason for this special situation is because Veitshöchheim was not a residence that was intended to express state power. In the seventeenth century the prince-bishops used the building as a temporary hunting lodge and it was not until 1749–53 that Carl Philipp von Greiffenclau commissioned Balthasar Neumann to extend it into a summer residence. The park in its present form was created from 1763 under Prince-Bishop Adam Friedrich von Seinsheim. Remarkably it has been open to the public since 1764. The lavish extension of Veitshöchheim is in fact astonishing because just a few years earlier, between 1733 and 1744, the stately summer residence Werneck Palace, near Schweinfurt, was built by Balthasar Neumann for Friedrich Carl von Schönborn.

This *maison de plaisance* with four projecting blocks has an unusual façade because two wings have been added to the original building. Balthasar Neu-

The playful elegance of the Rococo: figures such as this dancing Mercury by Ferdinand Tietz are veritable hallmarks of the court garden at Veitshöchheim.

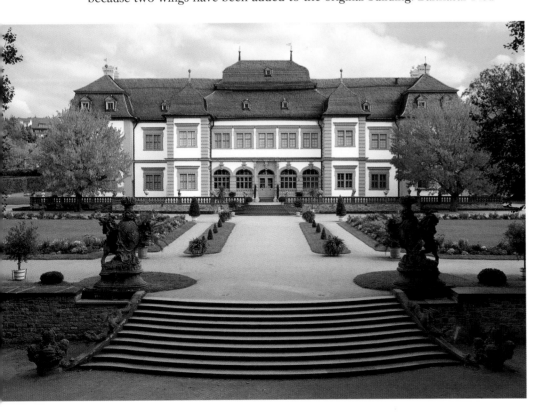

Balthasar Neumann transformed a former hunting lodge into the small summer residence of Veitshöchheim near Würzburg.

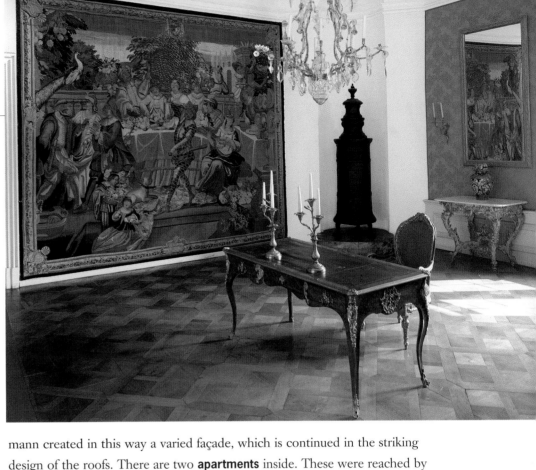

The apartment is appointed with fine furniture and eighteenth-century tapestries. A chair in the chapel can be turned into a prie-dieu by folding down the back-rest.

The living quarters of Grand Duke Ferdinand of Tuscany, on the other hand, were refurbished later, in the Biedermeier style.

mann created in this way a varied façade, which is continued in the striking design of the roofs. There are two **apartments** inside. These were reached by flights of steps, which have been skilfully integrated into the two-storey staircase. A **chapel** was included in the prince-bishop's apartment. Its walls are covered with embossed and polychromed wall hangings made of kid leather that were produced in 1725 in Mechlin. The furnishing of the former guest-rooms in the north wing dates back to the time between 1806 and 1814, when Grand Duke Ferdinand of Tuscany resided here. The contrast to the courtly Rococo of the prince-bishops could hardly be greater. The impression is determined by the densely patterned wallpaper and the Biedermeier or Empire-style furniture. In fact here bourgeois taste has prevailed, where basic comfort is given priority over pomp and display.

A stroll through **Veitshöchheim Park** is certainly one of the most stunning experiences of an art tour in Franconia. This is not only because the most important German garden sculptor, Ferdinand Tietz, who was court sculptor in Bamberg, created his major work here, but also because of the layout of the

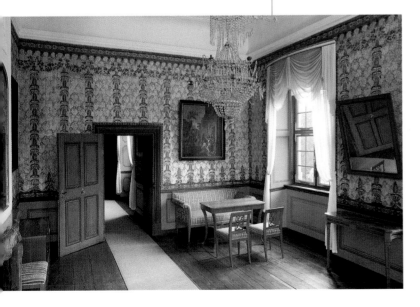

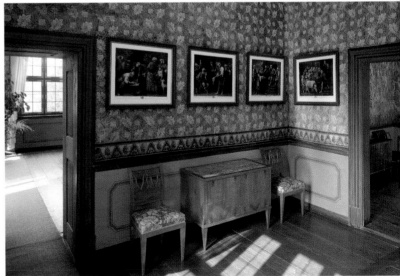

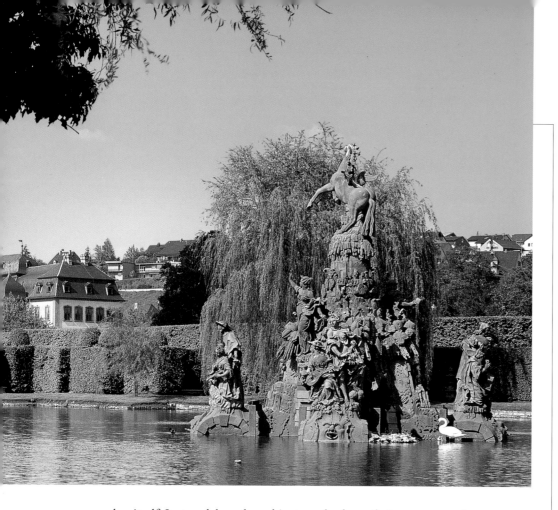

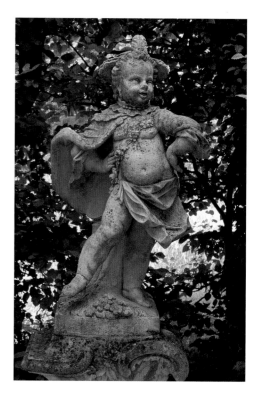

Mount Parnassus rises up in the middle of the Great Lake, located at the centre of the park. Like all the statues in the park, of which the dancing children in courtly attire are the most famous, it was made by court sculptor Ferdinand Tietz.

garden itself. Its two lakes, the cabinets and salons, their avenues and open spaces, the hedge theatre and the grotto-house transport the visitor into another world, one that is cut off from the everyday reality of the world outside. Allusions to the imperial house and concrete political statements, similar to those in the city residence, are sought here in vain. The references are instead to mythology, the world of ancient heroes and gods, which are integrated in the allegorical cosmos of the Baroque.

The starting point for the programme of figures is the **Great Lake**, which is about one hundred and fifty metres long. In the centre of the basin **Mount Parnassus** rises up. The Roman poet Ovid recounted that after a deluge it was from Parnassus, the mountain of the Muses, that a new world order emerged. The winged horse Pegasus, which was once gilded, rears upwards from the summit towards the mountain of the gods, Olympus. His lord is Apollo, who is shown with the Nine Muses gathered around the rock. The waves and spray of the deluge are insinuated by the waterworks. When these are started, the entire

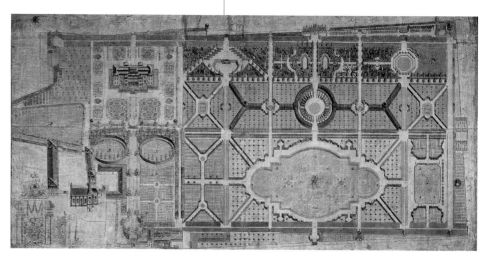

A ground plan from around 1780 shows the park's layout, which is largely retained today.

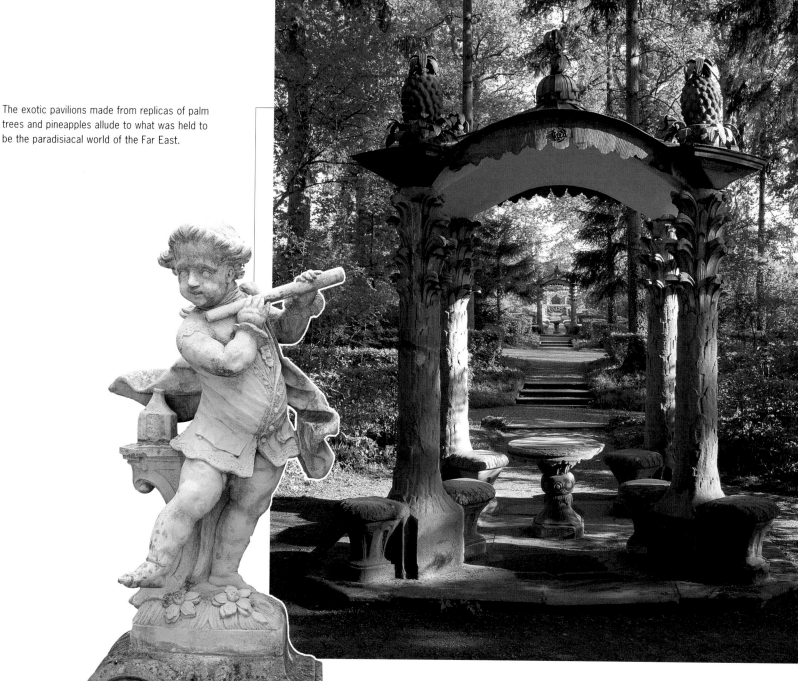

The exotic pavilions made from replicas of palm trees and pineapples allude to what was held to be the paradisiacal world of the Far East.

scenery is transformed into an animated Baroque spectacle. Other Olympian gods line the route around the lake together with allegorical figures of the arts and the seasons.

Earlier it was mentioned that there are no political allusions in the garden iconography of Veitshöchheim, but this claim now has to be amended. The glorification of a new world order, to which Parnassus alludes, relates also to the prince-bishop. Just as a golden age dawned at that time and the arts flourished, the accession of Adam Friedrich von Seinsheim heralded a new age of peace and cultural upsurge. At least this is the message of the sandstone sculptures.

To the east of this part of the park is the so-called **arbour area**. A linden avenue, with treetops that have grown together forming an enfilade with a compelling sense of perspective, divides up the two zones. At the centre is the Great Circus, or the Grosses Rondell, as it is also called. This area is surrounded by linden trees clipped in Baroque style. The Circus is to a certain extent the park's festival hall, something that is also indicated by the figures. There are allegories of the four continents, referring to the power claims of the absolutist ruler, accompanied by dancers and musicians.

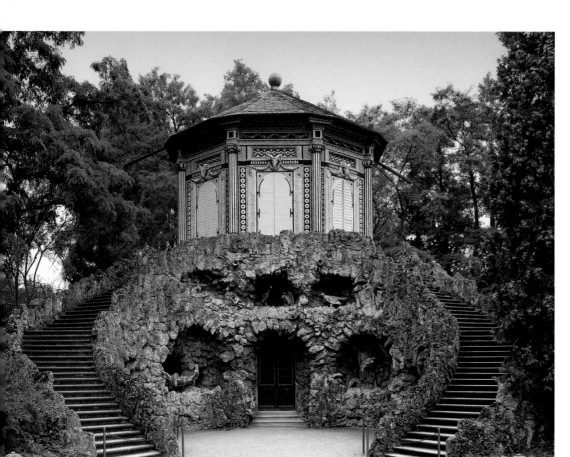

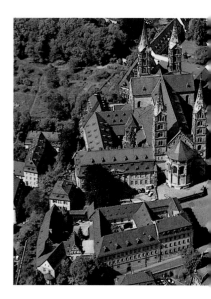

In the south-east section of the park a belvedere was built above a man-made grotto.

From the south and north of the Circus two arbour areas emerge on either side in mirror image. These lead you first of all to a **cabinet made from hedges**. This topiary section, which surrounds a small fountain, does in fact evoke the impression of an interior. Moving on you come to wooden **pavilions** with ceilings bearing scenes of the gods from Ovid's *Metamorphoses*. Larger **arbour zones**, also embellished with sculptures, are situated on either side at the edge of the park.

Beyond a spruce avenue to the east, one finally comes to the woodland. Today these three zones have been largely preserved. The central axis is bordered by the **wood**, where secluded clearings provide space for two springs and two **Chinese pavilions**. These are constructed of sandstone palms supporting a Chinese roof. To the south animals are grouped in a **salon** and relate to the moralising fables of Jean de La Fontaine. The **hedge theatre** is to the north and is one of the few remaining examples of its kind, which were extremely popular in the eighteenth century.

Finally the **grotto-house with the belvedere** above, which forms the conclusion of the park in the south-east, deserves a mention. You must take a good look at the open space of the grotto because there are some surprising things to be discovered. The artificial rock crevices are inhabited by wild creatures, such as monkeys, lions and dragons—but all are made of stucco. All the furnishings, even the chandelier, are embellished with shells.

The tour through this unique park at Veitshöchheim, Germany's Rococo garden *par excellence*, transports us to a distant world, to the playful realm of fantasy so beloved in the eighteenth century. One is almost tempted to term this garden, with its open spaces, corridors and cabinets, a fairy-tale palace grown out of trees, bushes and flowers.

The cathedral and the Baroque façade of the New Residence form an impressive ensemble that dominates the skyline of Bamberg's Old Town.

BAMBERG

This bird's-eye view shows how ingeniously the New Residence and rose garden were linked up with the original ensemble of cathedral and Old Episcopal Residence.

Archaeological excavations have revealed that the origins of this city must date back to the pre-Carolingian period, when a settlement grew up along the banks of the River Regnitz. The remains of foundations of fortifications on the hill, the Domberg, are dated somewhat later, around 800. However, it was not mentioned in a written source until 903. In reference to the so-called Babenberg Feud, the Domberg was termed "Castrum babenberch", from which the city's name derives. In 973 or 975 it was finally ceded to Bavaria. Duke Henry of Bavaria and his wife Kunigunde then laid the foundation stone for the city's future prosperity and the political and cultural florescence that accompanied this, making Bamberg one of the first cities in the German empire. After becoming King, Henry II founded the bishopric of Bamberg in 1007. The election of Bishop Ekbert, a member of the princely house of Andechs-Meranien, in 1202, marks the beginning of the tradition of uniting secular rule with the episcopate, establishing the prince-bishopric of Bamberg. It is thanks to him that the rebuilding of the cathedral, begun in 1180, was energetically continued.

The four cathedral towers rise far above the charming silhouette of the city. The Romanesque building with its two choirs is one of the most significant religious buildings in Germany. Of equal quality are the sculptures with which it is richly adorned, such as the equestrian sculpture of the *Bamberg Horseman* (Bamberger Reiter) or the tomb that Tilman Riemenschneider created for the donors, Henry and Kunigunde, almost five hundred years after their death.

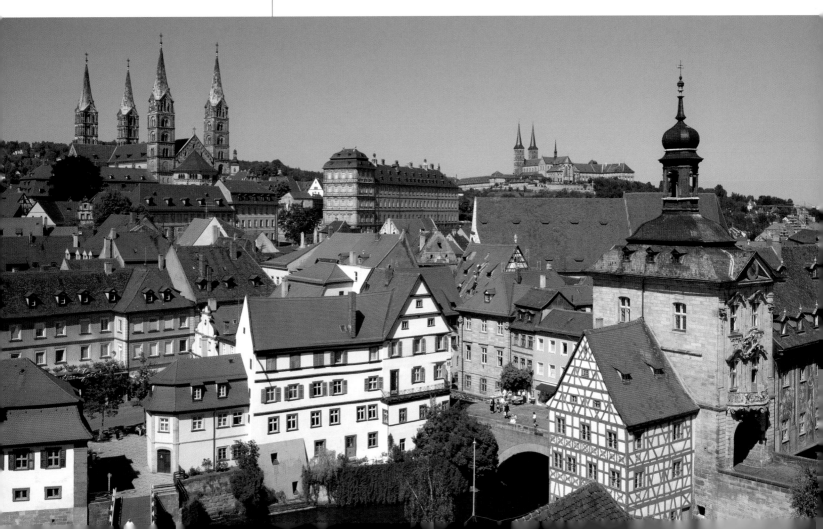

The Old Episcopal Residence

The cathedral is adjoined to the north by the Old Episcopal Residence (Alte Hofhaltung) of the Bamberg prince-bishops, an ensemble of buildings that evolved over many centuries into the impressive complex that we admire today. The origins date back to Henry II, who built an imperial palace here. It is only in the St Thomas's chapel (Thomaskapelle), consecrated in 1020 and later much altered, and in the remains of the palace from the second half of the twelfth century that the majesty austerity of the Romanesque can still be clearly detected.

In the late Gothic period between 1479 and 1489, the Old Episcopal Residence was extended to the north by building residential and utility buildings. This fundamentally transformed its character, as now pointed gables and galleries dominated the courtyard façades. Originally the courtyard was almost entirely surrounded by the new buildings—their "old Franconian" beauty still inspires admiration today. The ground floors are all made of sandstone. Here

The Old Episcopal Residence, with its picturesque residential and utility buildings, is a veritable town within the city.

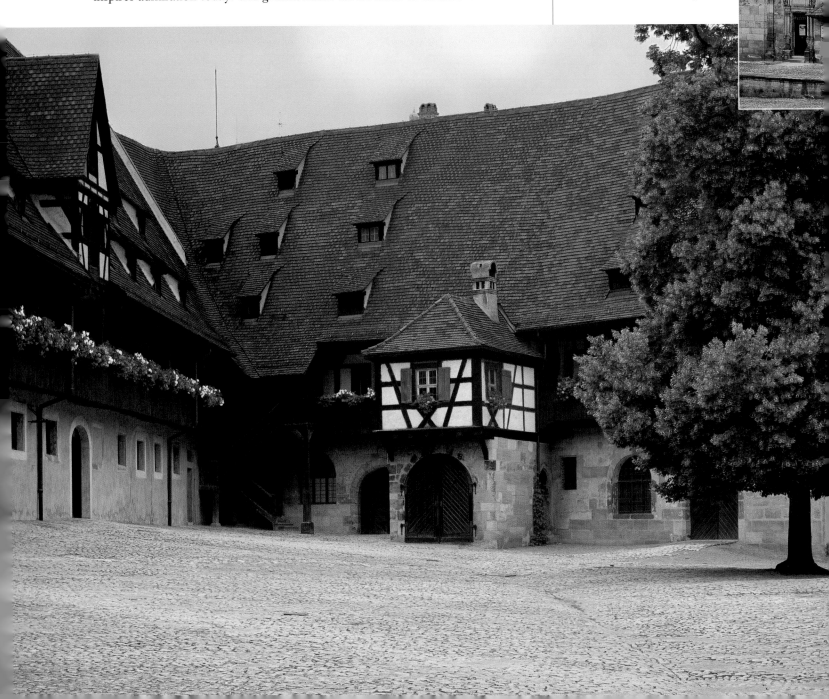

The Old Episcopal Residence was given a facelift in the late Renaissance and lent representative façades to fulfil the new need for princely display.

were the stables, kitchen, cooperage, forge and other workshops. The buildings rise above this with one or two storeys in half-timber work. The servants' quarters, which are housed there, are accessible from the outside via wooden galleries. The steep roofs are striking and conceal skilful trusses of a type introduced in the Gothic period. The numerous small windows were for ventilation. Provisions for both man and beast, especially corn and hay, could be pulled up by hoists attached to the central gables and stored in the vast loft.

Just under a century later—in the late Renaissance—there was again a drastic reorientation. The alignment of the Old Episcopal Residence towards the inner courtyard was radically rethought and opened up with the discovery of a new area for construction outside the square between the Old Episcopal Residence and the cathedral. This had grave consequences, not only with regard to the existing buildings, because parts of the late Gothic Episcopal Residence were demolished, but also because it dictated the architectural plans for centuries to follow. The traditional character of the Old Episcopal Residence as a town in the city, which is typical of medieval castles and fortresses, was superseded by the need for princely display. The prince-bishop no longer wanted to withdraw behind walls but to be seen in the glory of his power. This stately new building was commissioned by Veit II of Würzburg between 1561 and 1577. It housed a chancellery, a library, St Andrew's chapel (Andreaskapelle) and, of particular interest, the New Council Chamber (Neue Ratsstube). Of this picturesque ensemble of buildings, which is recorded in old illustrations, all that has been preserved is the council chamber with the **Beautiful Gate** (Schöne Pforte) beside it, which still provides access to the Old Episcopal Residence. The other parts of the Renaissance building had to be demolished in 1777 because of their dilapidated state.

Yet the bishop certainly did not live in the Old Episcopal Residence. This was merely his stately office building. His apartment was in one of the curia buildings near the cathedral. The need for display, which had increased since the sixteenth century, especially on account of the bishop's function as a secular ruler, was matched by the wish for a residence of his own, a residence that was truly worthy of his name. A suitable setting was found on the so-called **Geyerswörth**, a name in old German amounting to Geyer's island. Situated in the River Regnitz, the island was the site of a small, four-winged building that had once belonged to a family called Geyer. In 1580 the building was acquired by the *Hochstift*, or bishop's principality, and remodelled. The garden was famous, but this has not been preserved. By moving into this new residence the Bamberg prince-bishops took the same step as other princes in that decade. They moved out of their now old-fashioned castles—or in this case the curia buildings—into noble, new premises in the city.

The New Residence

But then something unexpected happened. The same prince-bishop who had commissioned the Renaissance garden on the Geyerswörth, Philipp von Gebsattel, soon returned to the Burgberg. In 1599 he had acquired a relatively large curia building on the Domberg. Its location next to the Old Episcopal Residence and opposite the cathedral dictated in one fell swoop the later function of the square in front of the cathedral—it was to become a *cour d'honneur* of the future residence. Philipp von Gebsattel immediately started the remodelling of his New Episcopal Palace and he and his successor erected two vast tracts at the back of the complex.

Accustomed to large, modern buildings, viewers today may not be readily impressed by these wings of the residence with their lack of structuring and seemingly endless rows of windows, but at the time their monumentality was something completely new. Even one of the most famous buildings of the day, the Escorial, which had been completed a few decades earlier for the Spanish king, reflects similarities. Possibly this even influenced the New Episcopal Residence. The continuation of the residence wings opposite the cathedral was hindered by the Thirty Years' War.

Four decades after the end of the war, the political and economic situation had been consolidated to such an extent that there was a resurgence in palace building in all regions of the empire. However, in Bamberg building was

Seehof Palace, the magnificent summer residence of the Bamberg prince-bishops, is situated in a vast park.

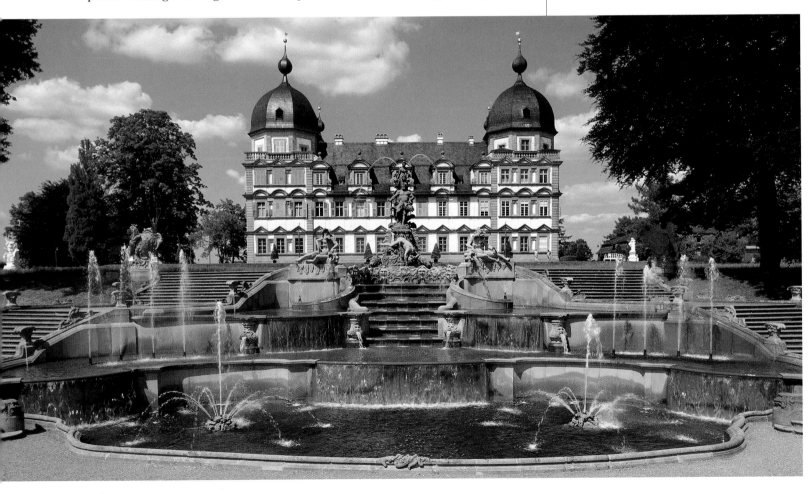

not resumed on the Domberg but a long way in front of the city gates. Prince-Bishop Marquard Sebastian Schenk von Stauffenberg commissioned Antonio Petrini, architect from Würzburg, to build between 1687 and 1696 the Marquardsburg, today known as **Seehof Palace** and a popular place for excursions. From then on Seehof was the summer residence of the prince-bishops of Bamberg. Whoever comes here with Veitshöchheim in mind, the Würzburg summer residence, and expects a similarly intimate building has quite a surprise awaiting them. In the centre of an opulent park with basins, a cascade and groups of figures, there is a proud four-winged building with corner towers. The striking difference between both residences—here a symbol of power visible from far off, there almost private seclusion—reflects a fundamental change in requirements over a good half century.

A painting of 1764 by Joseph Christoph Treu depicts Seehof Palace as seen from the Bamberg Residence, where the painting hangs today.

Back to the cathedral square, or Domplatz. For almost one hundred years the half-timber old curia building was situated opposite the cathedral. Yet only two weeks after Lothar Franz von Schönborn was elected prince-bishop of Bamberg, in 1693, plans for the completion of the residence were again set in motion when he appointed the architect Johann Leonhard Dientzenhofer. Now the residence was not only to take on immense dimensions, but it was also to form an ensemble with the imperial cathedral—a symbol of the power relations of the day, the union of state and church. The imposing site above the city underscores this statement. These ambitious plans dictated that the **New Residence** was to be Dientzenhofer's key work. Apart from the extension at the

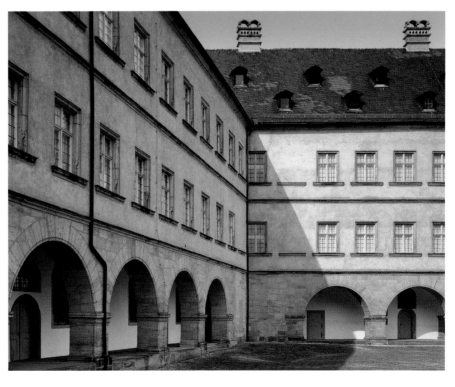

The sprawling wings that frame the courtyard of Bamberg's New Residence were erected around 1600 in the style of the German Renaissance.

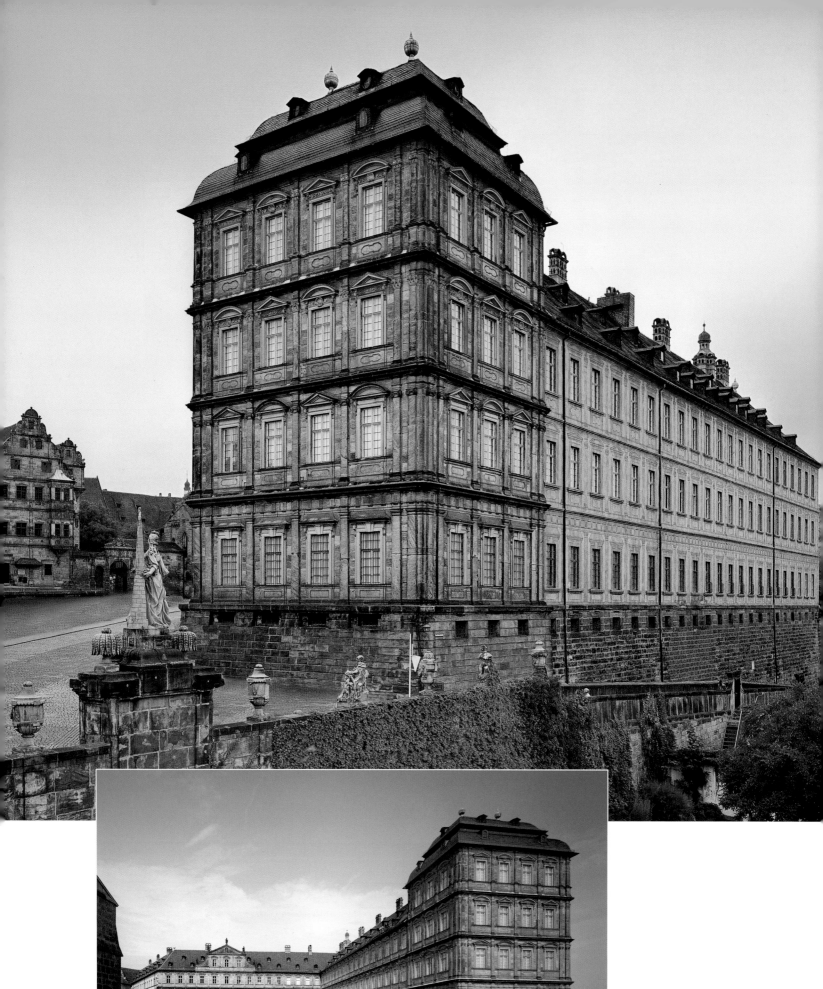

The façade of the so-called Schönborn Building in the New Residence stands proudly above the city and can be seen from a great distance; on Domplatz the building opens on to a *cour d'honneur*.

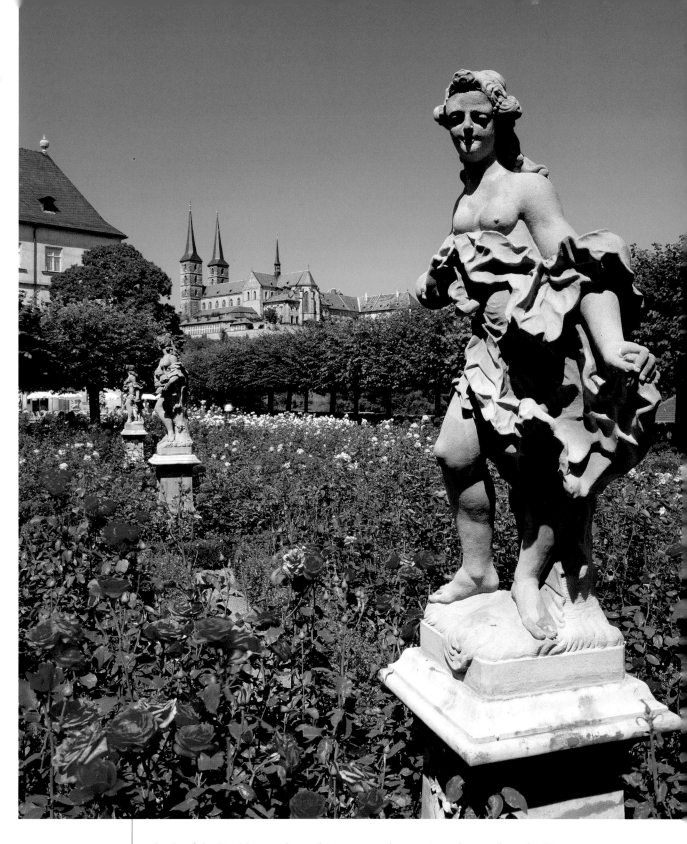

Behind the wings of the Residence lies the popular rose garden, which contains a Rococo garden pavilion and statues by Ferdinand Tietz.

back of the Residence, the architect erected two wings that enclose the Domplatz to the north and east towards the city. Like the two existing tracts they have three storeys, but are more richly structured, with pilasters. Directly opposite the cathedral in the north wing is the entrance portal, accentuated by a fronton, while the four-storey **Pavilion of the Fourteen Holy Helpers** (Vierzehnheiligenpavillon) concludes the building in the east.

The construction work must have been well planned because it took only three years to complete. With this extension the Residence acquired two different aspects. Facing the forecourt it formed together with the Old Episcopal Residence and the cathedral an almost enclosed space, vividly enlivened with diverse architectural forms spanning about half a millennium. By contrast, the

41

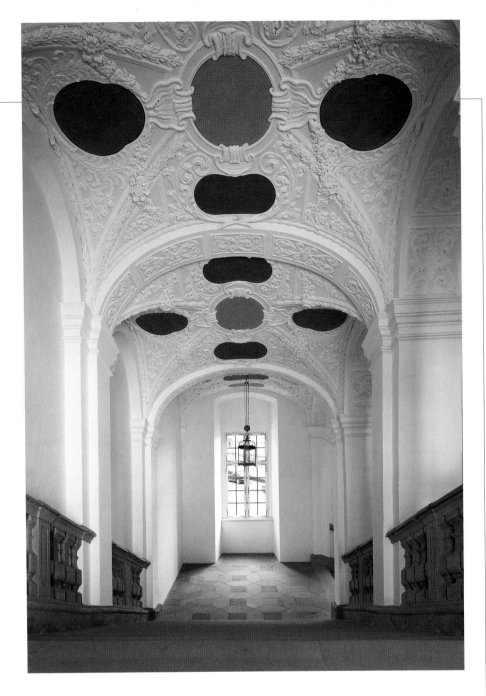

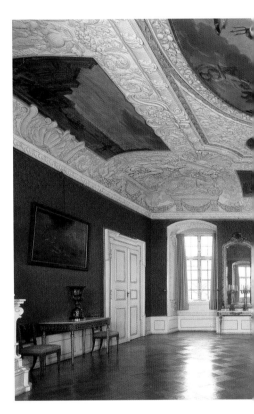

Compared to the ambitious size of the Residence, the dimensions of the staircase are remarkably modest.

The dining room in the Prince-Bishop's Apartments is still graced with the late Baroque stuccowork dating from its construction, after 1703.

inner courtyard with its charming **rose garden** opens out to a panorama over the Old Town and the surrounding countryside. Hence the prince-bishop's Residence, which at first glance appears to be an almost random hotchpotch of buildings, under closer scrutiny is in fact a classic example of Baroque architecture and spatial design. After the death of Lothar Franz vast extensions of the Residence were planned, but in fact only isolated modernisations were undertaken to conform with the tastes of the day.

The interior of the Residence, with the Prince-Bishop's Apartments, the Emperor's Apartments (Kaiserappartement) and the Elector's Apartments (Kurfürstenzimmer), is accessible via several staircases. Like the rest of the building the **Grand Staircase** can be described as solemn and dignified. Through the central stairwell and the vault supported by pillars there are a multitude of new spatial impressions and glimpses upwards as you climb the stairs. The sculptural stucco ornaments of various plants, interspersed with flying putti, give the impression of festive decorations honouring the prince-bishop and the emperor.

The **Prince-Bishop's Apartments** is on the first upper storey. Because this was used most, there are a comparatively large number of changes from later

In the White Hall, refurbished in 1773, the
Baroque style gives way to early Neo-
classicism, with its simple, continuous off-
white stuccowork.

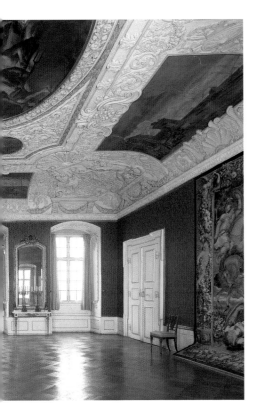

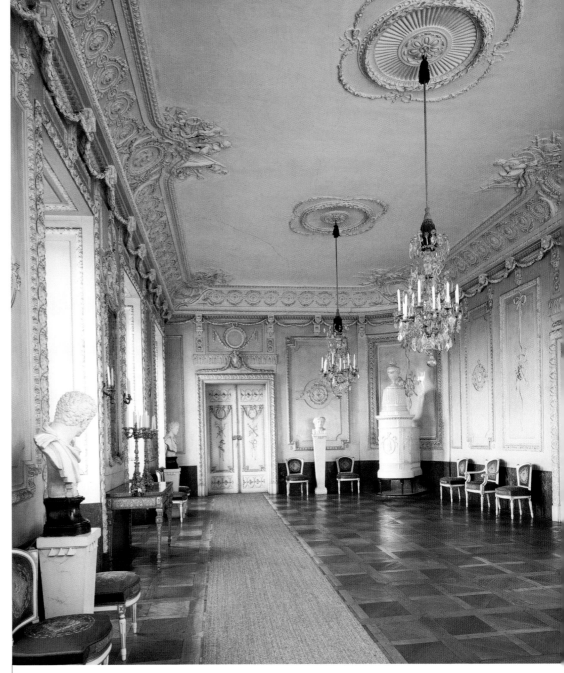

In the dining room the prince-bishop
had *vedute* of southern ports let into the
ceiling's stuccowork.

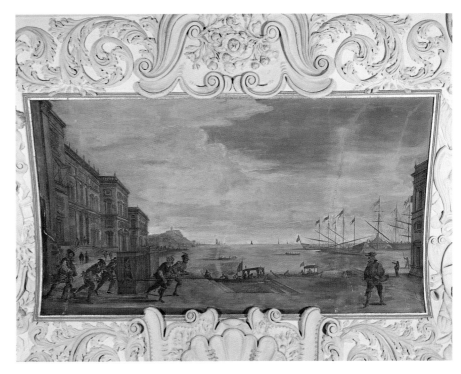

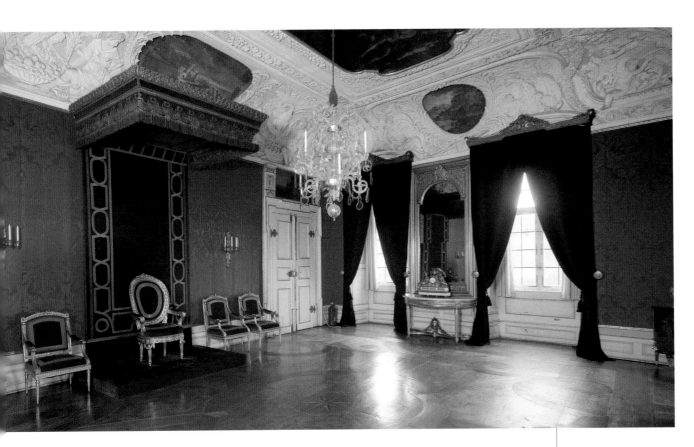

periods. Even in the first four rooms the visitor is made acquainted with three artistic styles. Whereas in the outer anteroom the sculptural stucco has been largely preserved from the time of building, just after 1700, the next room, dating from thirty years later, has been decorated in a style that is virtually Rococo. The two rooms at the back demonstrate by contrast the cool elegance of the Empire style of around 1773.

Following the large **dining room** and another anteroom, one arrives in the **Audience Room**. What stands out here is the ceiling painting with the Olympian gods. When the prince-bishop commissioned this painting here, where the power of the state is represented, there was of course a message that he wished to convey: he was such a great and wise prince that even the gods assembled under his roof. Interestingly it is the pagan gods of antiquity that gather around the bishop. Depicting the Christian God would have been regarded as blasphemous in such a context.

Of great art-historical significance is the next room, the **Chinese Cabinet** dating from 1700 and most probably the first room of this kind in Germany. Unfortunately, it is not known what made Lothar Franz transplant to Bamberg this type of room from Holland, where such cabinets had been popular for some time. It was not until later in the eighteenth century that Chinese-style rooms became a great vogue in the German-speaking world.

At the end of the Prince-Bishop's Apartments there are three smaller rooms that are dedicated to King Otto of Greece. The second son of King Ludwig I of Bavaria, Otto was deposed as the Greek regent by a military revolt in 1862 and was given the Bamberg residence as a palace for himself and his wife. Even if he had been robbed of all authority, he retained the Greek court ceremonial here in the heart of Franconia until his death in 1867.

The rarely used **Emperor's Apartments** are situated above those of the prince-bishop. First of all you enter the one-storey and therefore rather low **Emperor's Hall**; this evokes a completely different spatial impression after the

44

The representational Prince-Bishop's Apartments culminate in the Audience Room, which houses the throne baldachin.

right: The term "Chinese Cabinet" alludes to the fifty Delft and eighteenth-century East Asian ceramics that once graced the room.

Following his abdication, Wittelsbach King Otto of Greece and his wife resided several years in the Residence.

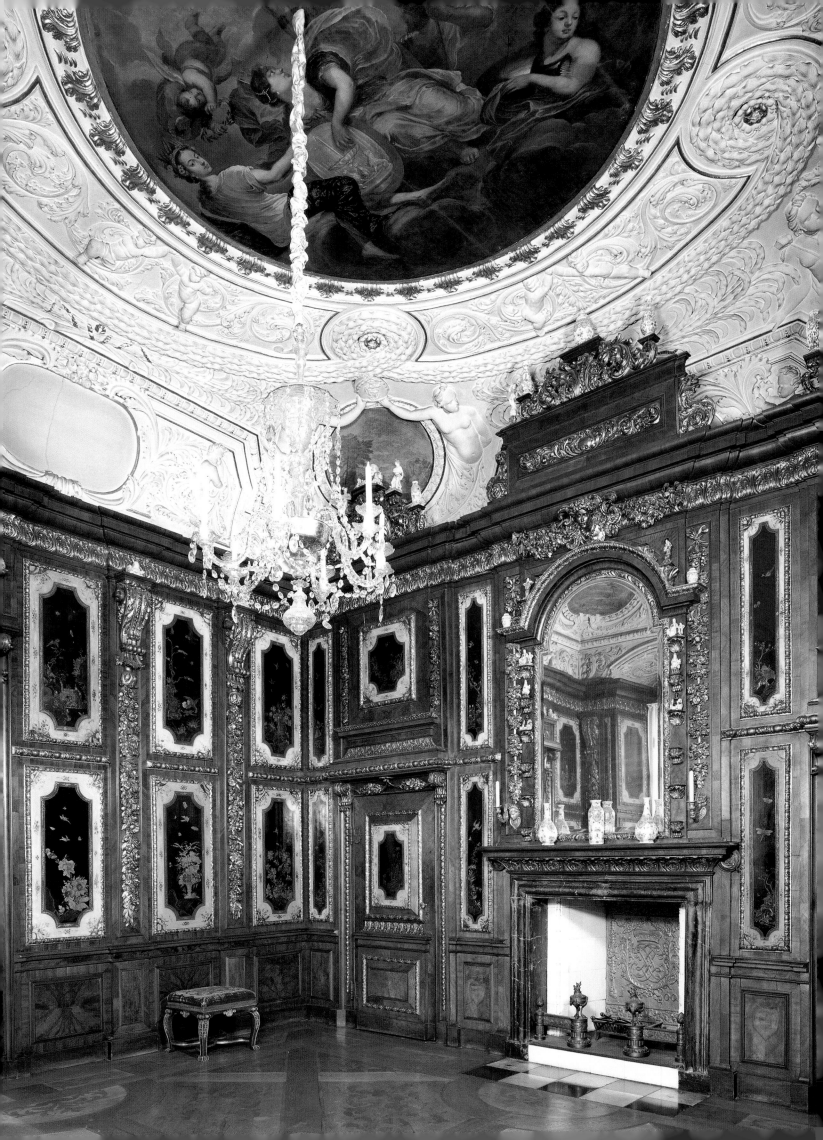

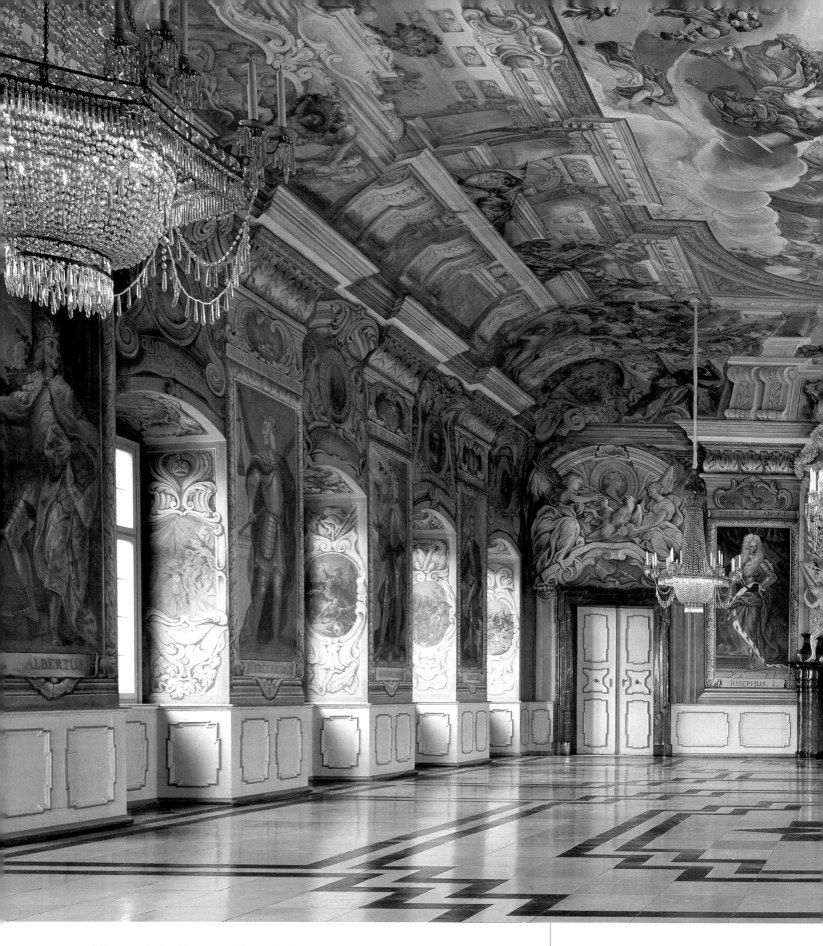

With *trompe-l'œil* architecture and figure painting
Melchior Steidl transformed the otherwise almost
unadorned Emperor's Hall into a magnificent
Baroque interior.

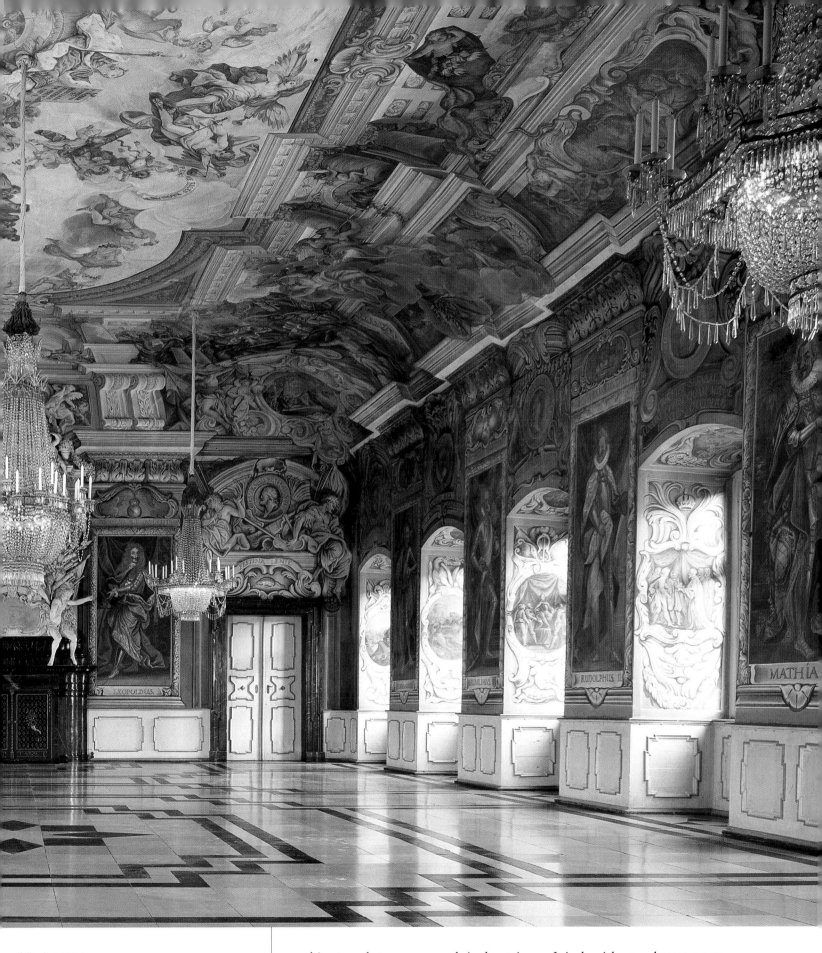

architecture that soars upwards in the staircase. It is the richest and most ornately decorated room in the Residence, the pompous prelude to the Emperor's Apartments beyond. It was intended to accommodate members of the imperial house when visiting. Here the close connection between the Schönborn family and the *Reichsstift* with Vienna was publicly proclaimed and tribute was paid to the House of Habsburg. The paintings of 1707–9 by Tyrolean artist Melchior

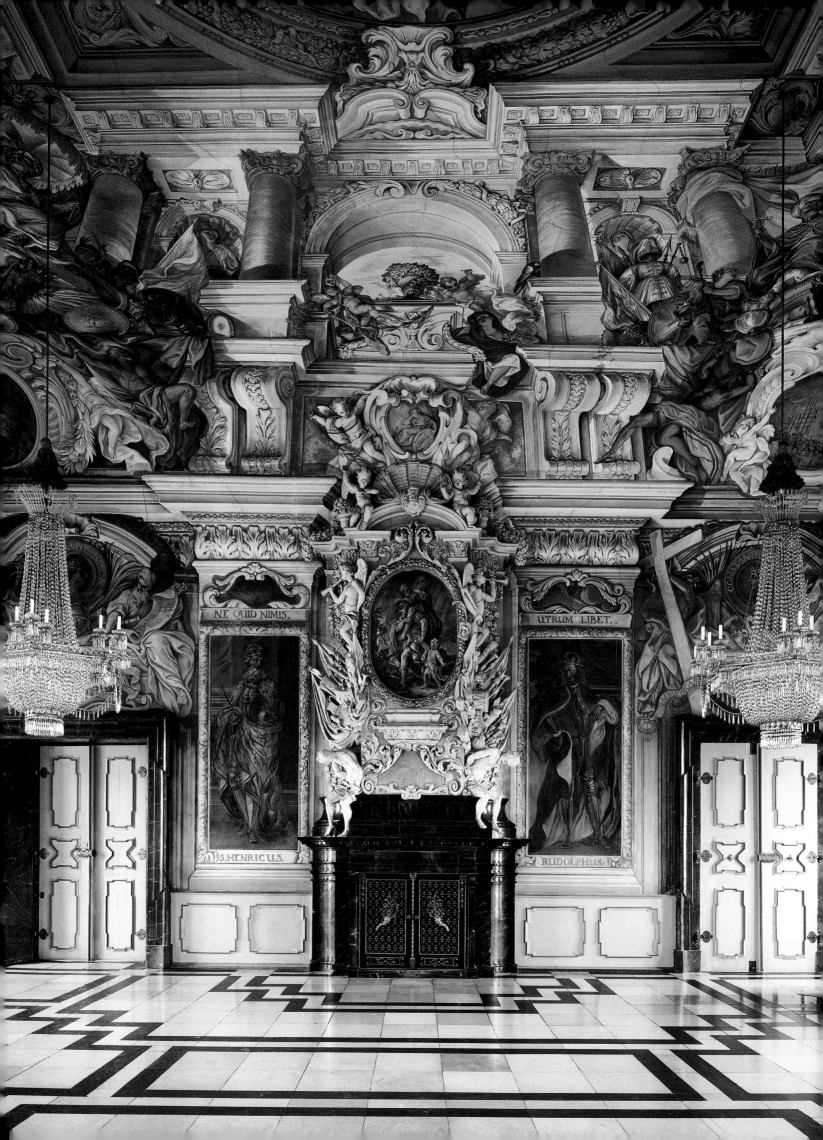

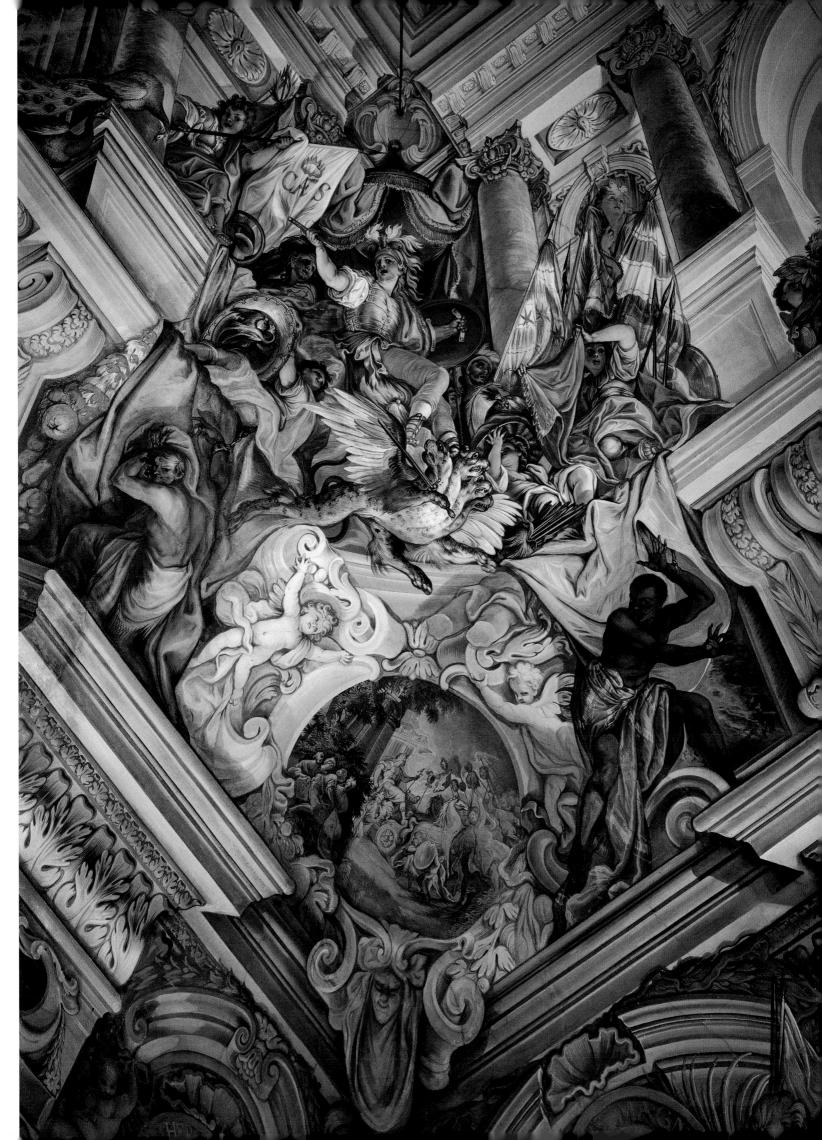

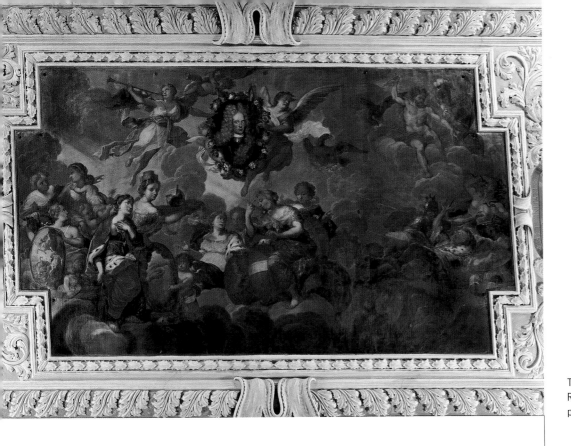

Steidl served this purpose. The complicated pictorial programme was probably conceived by Lothar Franz himself. The depiction of Roman rulers was intended to indicate that they were the forerunners of the German emperors, who are shown as life-sized figures. This expresses the idea of the medieval relocation of the Roman Empire to Germany, which explains the origin of the term

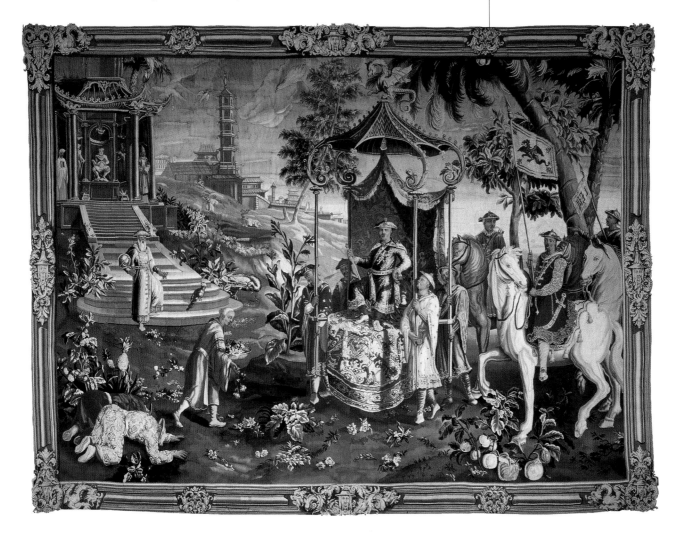

The Elector's Apartments are located in the oldest wing of the Residence.

"Holy Roman Empire of the German Nation". On the ceiling painting the personification of Good Government, an allegorical transfiguration of the House of Habsburg, flies through the sky on a golden chariot.

Still in the spirit of the seventeenth century are the paintings in the **Emperor's Room**, two rooms further on. Sayings and emblems with symbolic allusions, which were so popular in the Baroque period, glorify the reigning Emperor Joseph I. A detailed interpretation of these images has revealed possible encoded criticism of the Emperor's stance in the War of the Spanish Succession. Only one or two years before this room was painted, the war's decisive Battle of Blenheim took place nearby, in which the Bavarian army under Elector Maximilian Emanuel suffered a devastating defeat.

Through the almost undecorated corridor in the southern tract of the Residence one arrives in the **Elector's Apartments** at the back of the west wing. These were the first of the three stately suite of rooms to be created. They were actually intended to provide a temporary apartment for Lothar Franz, until the extension of the Residence towards the Domplatz was completed—the part which we have just visited. However, the prince-bishop never contemplated moving in here. It was probably a way of pressurising the cathedral chapter, upon whom he was financially dependent, so that the extension would not be

51

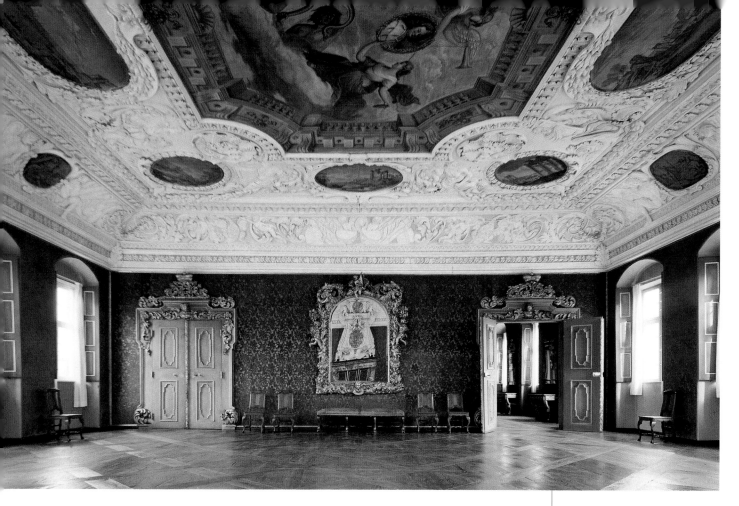

postponed. So the magnificent Elector's Apartments were actually used only to accommodate guests. As they were rarely used, hardly any alterations were made and there-fore, like the Emperor's Apartments, the original impression has been very well preserved.

The stuccowork is striking, with ceiling paintings set within this. The walls would originally have been adorned with embossed leather hangings. Today a fine series of Brussels tapestries hangs in a few of the rooms. They depict the heroic deeds of the Roman general Scipio the Elder. He conquered Hannibal, after he had almost caused Rome's downfall, and thereby laid the foundation stone of the Imperium Romanum. For obvious reasons many rulers wanted to be identified with him.

The first impression on entering the Elector's Apartments is of spaciousness. This is engendered by the harmonious proportions of the rooms as well as the broad corridor of doors linking them in an enfilade. The two anterooms are followed by the large **Princess Hall** (Prinzessin-Saal), which takes up the entire width of the tract. The ceiling painting shows the glorification of Prince-Bishop Lothar Franz von Schönborn. Via the audience room and the drawing room, one eventually reaches the bedroom. The original baldachin bed made of red velvet and the large mirror overflowing with gilded carvings both merit special attention.

Apart from the historic rooms the Residence also houses the important Staatsgalerie Bamberg, a branch of the Bayerische Staatsgemäldesammlungen. In this gallery Old German and Baroque paintings are exhibited.

The appellation "Princess Hall" can be traced back to Elisabeth Christine von Braunschweig-Wolfenbüttel, who lived within its walls for several days in 1708 before marrying Emperor Charles VI.

ASCHAFFENBURG

Johannisburg Palace

Not quite as old as Bamberg or Würzburg, Aschaffenburg can nevertheless look back on a history that dates from the ninth century. Obviously this royal demesne must have developed rapidly because only one hundred years later it was termed a town. The stage for further development was set around 982, when the collegiate foundation, established about three decades before, was given to Willigis, the Archbishop of Mainz. By building a bridge over the Main, constructing fortifications and incorporating suburbs, Aschaffenburg grew into an important political and economic centre. For over eight hundred years the lords of the city were the archbishops and electors of Mainz. They demonstrated their claim to power in this subsidiary residence by building a medieval castle. This stood for three centuries until it was largely destroyed in 1552. It was not until 1605 that the construction of a new palace could again be considered. In a period of nine years one of Germany's most important works of late Renaissance architecture was created in this commanding position overlooking the Main. The master builder was Georg Ridinger, who originated from Stras-

The silhouette of the proud Renaissance residence Johannisburg Palace, which stands on the banks of the River Main, dominates Aschaffenburg's townscape even today.

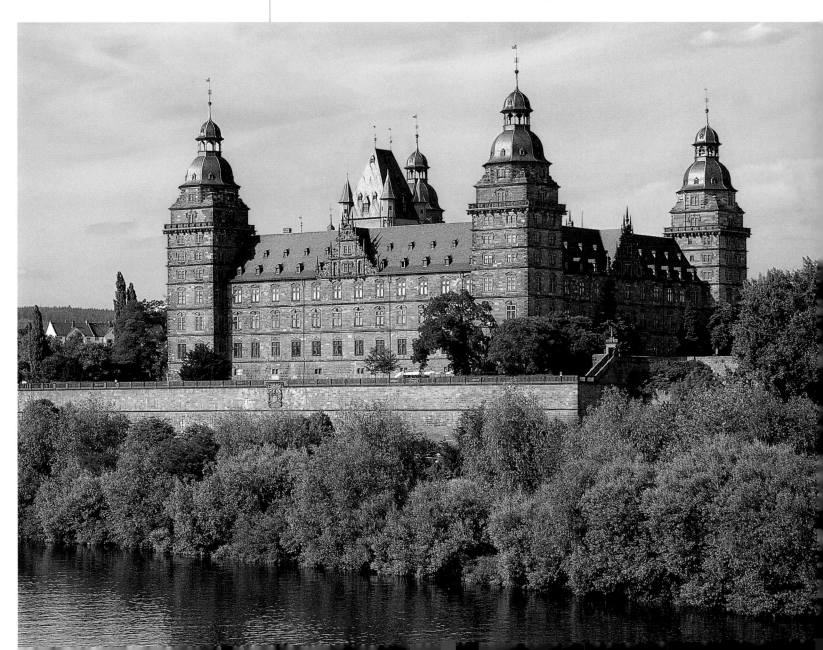

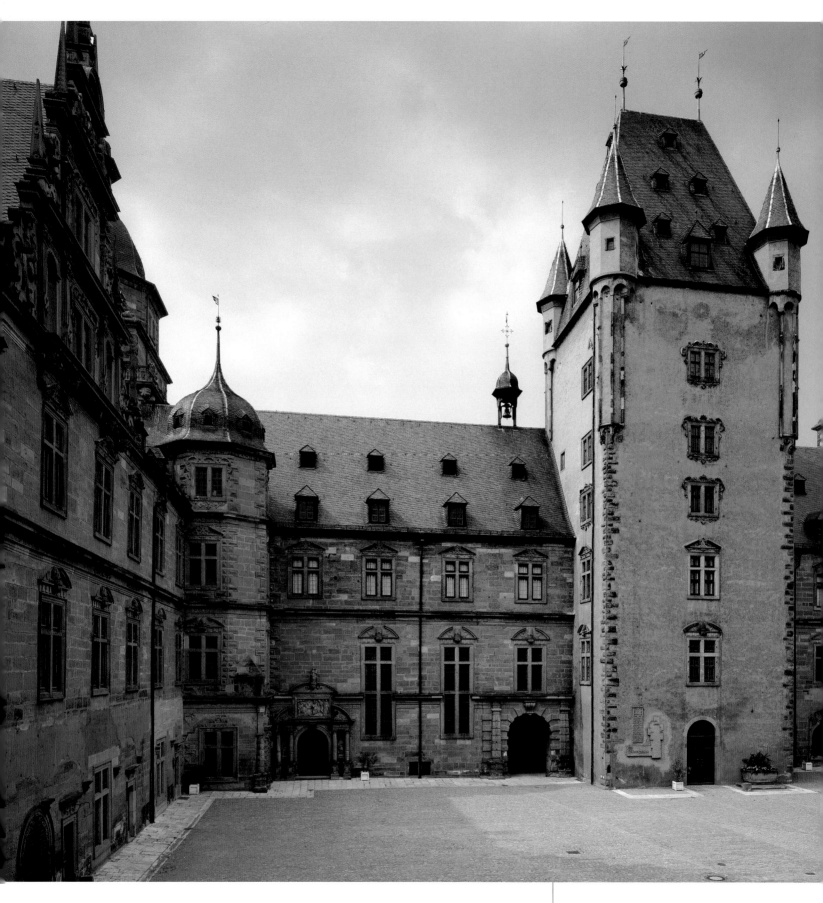

The medieval keep retained from the previous building bears witness to the long history of this princely seat.

bourg. By incorporating the keep of the previous building, he created with this four-winged building the first strictly symmetrical palace in Germany. Thus medieval architecture was left behind and a precedent for all future architecture north of the Alps established. Anyone who approaches **Johannisburg Palace** from one of the four sides will be impressed by the interplay of horizontals and verticals, of broad façades and the strong, soaring corner towers with double cupolas. Through the triumphal portal one enters the inner courtyard. As smaller

54

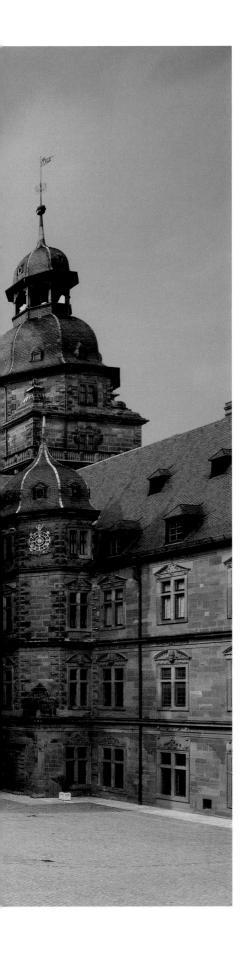

counterparts to the outer towers, stair turrets accentuate the corners, like a type of hinge between the four wings. The keep stands out opposite the main portal and appears almost crude beside the rest of the Renaissance design. It was integrated into the new building as a symbol of the time-honoured tradition of the residence.

To the left of the keep a change in the design of the walls can be detected. The tall windows belong to the **Palace Chapel**, which is the only room in the palace to have roughly retained its original form from the time when it was built. The splendid altarpiece was created by the Franconian sculptor Hans Juncker between 1609 and 1614. Alabaster reliefs with scenes from the Life of Christ are set in the room-high altarpiece made of black marble. The work is deemed by art historians to be one of the most important examples of early seventeenth-century sculpture in Germany.

The rest of the furnishings were renewed in the late eighteenth century in the Neoclassical style under Prince-Bishop Friedrich Carl von Erthal by the

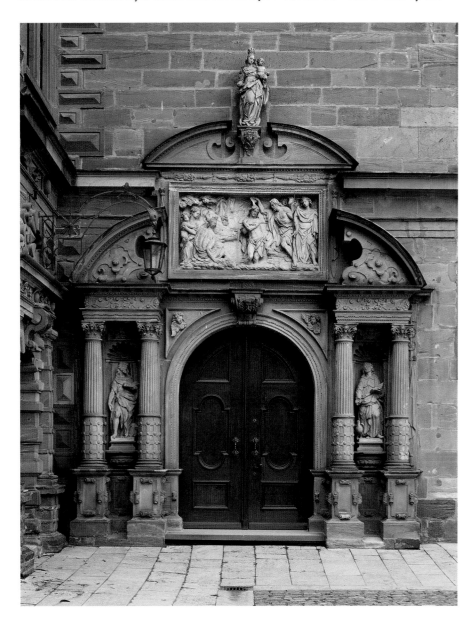

The portal of the Palace Chapel, which bears a relief of the *Baptism of Christ* by Hans Juncker, recalls a triumphal arch.

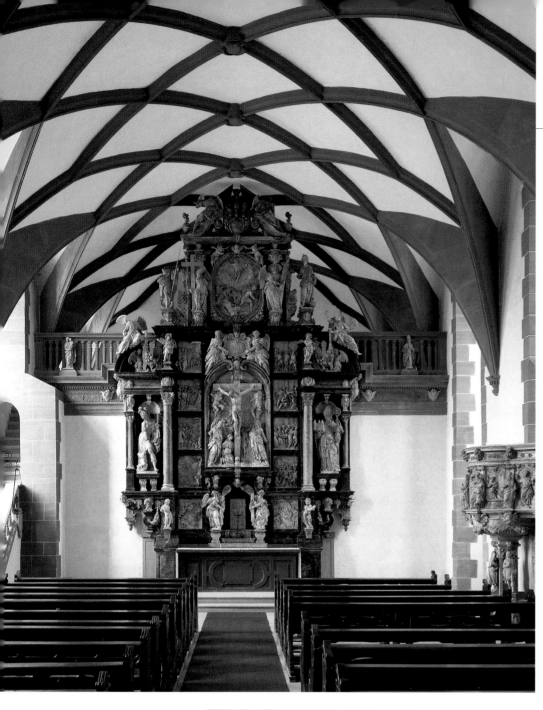

The figures and reliefs in this altarpiece by Hans Juncker re-enact the Passion of Christ.

After having been destroyed in the Second World War, the princely apartments, including the reception room shown here, were reconstructed and furnished with the surviving furniture.

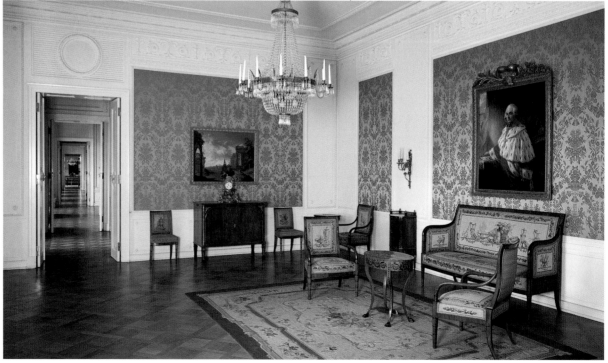

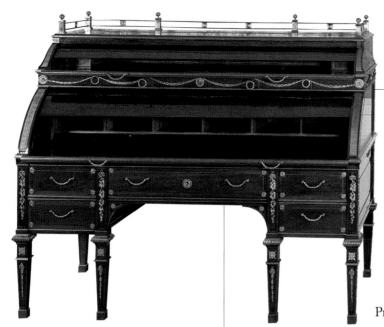

Cylinder bureau by Johann Kroll, 1783/84.

architect Emanuel Joseph Herigoyen. The following century brought more changes when Aschaffenburg passed to Bavaria and the palace was used by Crown Prince Ludwig as his summer residence.

The year 1945 appeared to mark the palace's end. Bombing virtually razed it to the ground. Only the outer walls remained. Because the furnishings had been placed in safety before, it was decided that the palace should be rebuilt. The state apartments were reconstructed and refurbished with the furniture, paintings and other artworks. The other rooms were designed as museum galleries. In the **Parament Room** (Paramentenkammer), where the liturgical robes were stored, the exhibits consist primarily of precious vestments from the former cathedral treasury in Mainz. In two other rooms the world's largest **collection of cork models** is on show. This unique assemblage of antique buildings from Rome is the result of a vogue in the nineteenth century to make copies of famous buildings in cork. In size, these models span from a few decimetres to three and a half metres. While these reconstructions were originally used for didactic purposes, today they impress the viewer because of the atmospheric realism of their designs. Other collec-tions are of Old German and Netherlandish paintings from the **Staatsgalerie** and the **Schlossmuseum** of Aschaffenburg.

A special attraction is the collection of cork models of Roman buildings.

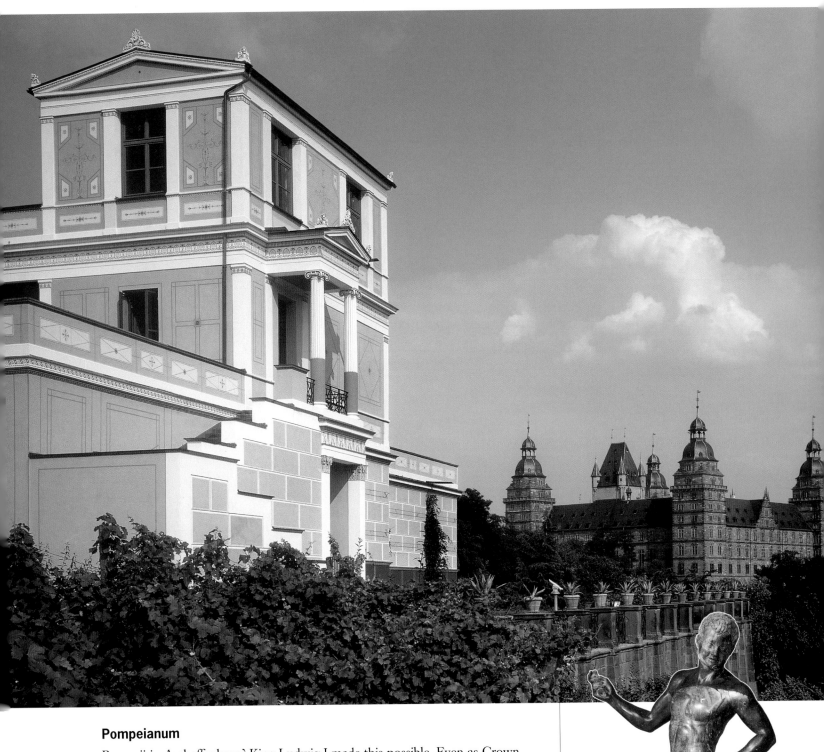

Pompeianum

Pompeii in Aschaffenburg? King Ludwig I made this possible. Even as Crown Prince he liked to sojourn in this city, which he termed "Nice on the Main". It was here that he realised his idea of erecting a replica of a Pompeian house. It was not intended as a private villa for the King but as a monument to Roman culture that was open to the public. To make the house appear as authentic as possible, Ludwig commissioned an art dealer in Rome to acquire all the utensils of everyday life from classical antiquity. Indeed the Pompeianum developed further the idea of the cork models, partly dating from the same time, but on the scale of 1:1. It was built between 1840 and 1848 by the architect Friedrich von Gärtner from Munich.

Above the vine-covered banks of the Main, the three-storey building looks as if it were stacked out of cubes. The walls are painted yellow and bordered with white, while the skirting-board is Pompeian red. On entering the building one indeed gains the feeling of being transported back to Rome two

The marble statue of a dancing satyr from Imperial Roman times is one of many works of art on display here.

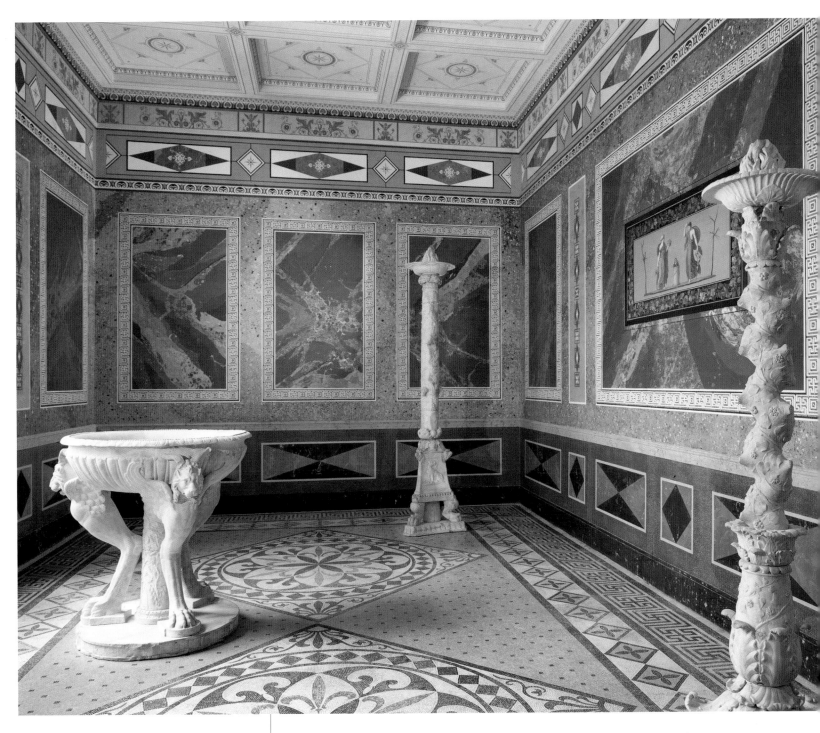

Most of the rooms, including the summer *triclinium*, or dining room, are adorned with stucco marble and mosaics.

bottom left: The Pompeianum, a replica of a Roman villa, is linked to nearby Johannisburg Palace via a passageway.

thousand years ago. Through a *vestibulum* (entrance hall) one arrives in the *atrium* (open columned hall). This is surrounded by several rooms, including three *cubicula* (bedrooms). The rear part of the house is centred around a *peristylum* (columned hall), which opens out to a *viridarium* (small garden). Alongside other rooms there are also two *triclinia* (dining rooms) here. All the rooms are furnished with works of art that have been supplied by the State Collection of Antiquities in Munich.

If we compare this reconstruction of Roman architecture with other copies of historic buildings erected by King Ludwig, such as those in Munich, the Walhalla near Regensburg or his villa Ludwigshöhe in the Palatinate, his attempt to be true to Roman architecture becomes apparent. The reason for this is that "Roman" meant more to him than merely a style. By picking up the threads of the distant past he also intended to express the ideal state, which in his opinion had been exemplary in Rome. The Pompeianum brought this notion closer to the population by lending it material form.

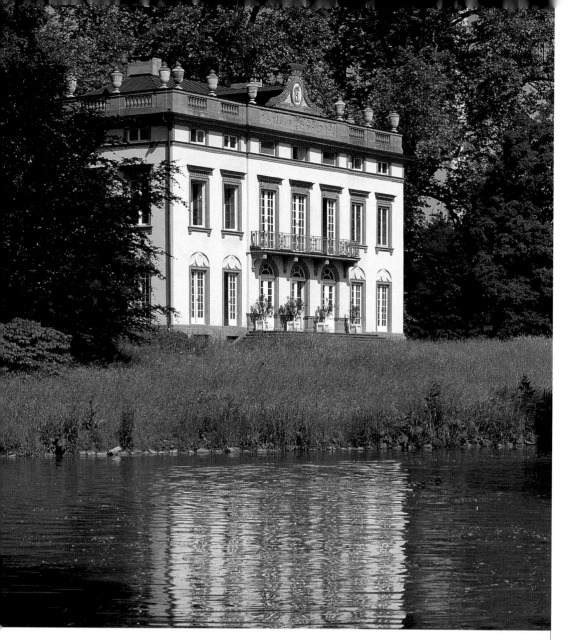

Schönbusch Palace is located in an idyllic park setting on the modern-day outskirts of Aschaffenburg.

Among the park buildings is an observation tower, where visitors can get a bird's-eye view of the park.

Schönbusch

The leap from Rome to England does not have to be far, at least not in Aschaffenburg. Today on the western edge of the city is Schönbusch, a park landscape with woods, meadows, lakes, a small palace and landscape architecture or follies. If you did not know that you were in the middle of Germany, you might assume that you were standing in the park of an English country house. No other place in southern Germany adopts the principles of the English landscape garden with the exactitude of Schönbusch—or so radically departs from the century-long norm of symmetry in garden design.

The origin of the landscape garden was a new, philosophically based attitude to nature, which evolved in the wake of the Enlightenment in England. Yet this innovation was not completely independent of tradition, even if the models that were frequently drawn upon were derived from another genre. These were the landscape paintings with Arcadian views by Netherlandish and French masters, first and foremost by Claude Lorrain. This explains why the segments of landscape that we glimpse from the many viewpoints in these gardens invariably appear like composed paintings, despite the naturalism.

Originally the hunting enthusiast Friedrich Carl Joseph von Erthal wished only to transform some woodland near his Aschaffenburg residence so that he

60

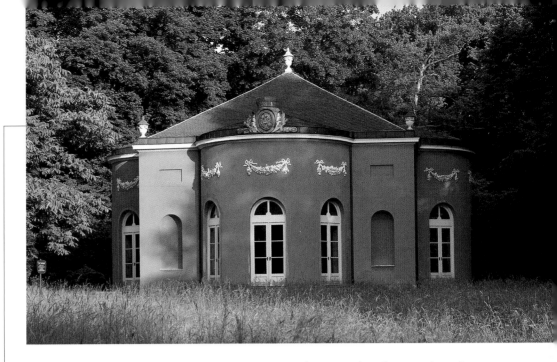

This little palace, called the "Dining Hall", was used on festive occasions.

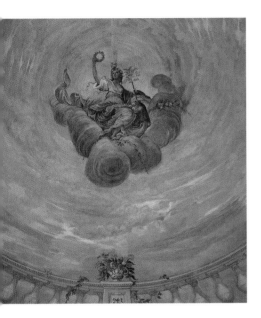

In the interior Edmund Seeland equipped the cupola with a depiction of the goddess Flora, who is shown perched on a cloud.

could pursue his passion. For this purpose in 1774, the year when he was elected Elector and Archbishop of Mainz, "hunting alleys" began to be cut into the wood to create a hunting ground with straight axes—in keeping with Baroque ideas. Yet things then turned out differently than expected. One year later the Mainz Minister of State, Count Wilhelm Friedrich von Sickingen, came up with the idea of remodelling the area as a landscaped park after the English model. To realise this, he initially enlisted the architect Emanuel Joseph Herigoyen, who simultaneously remodelled Johannisburg Palace in the Neoclassical style. Between 1780 and 1790 the landscape gardener Friedrich Ludwig von Sckell was in charge of the park's further development. Sckell had spent time in England, where he became familiar with the latest trends in garden design. With the English Garden in Munich, started immediately after Schönbusch, he became the most celebrated landscape gardener in Germany.

In 1776 there was the first mention of the name Schönbusch, which literally means "beautiful bush". This is notable because it makes no reference to the princes, as in the case of previous names (for example Karlsruhe) or an allegorical or mythological idea (such as Nymphenburg), but relates to nature without any of these glorifying allusions. And it is indeed true that in the English park, nature is always redesigned to conform with aesthetic notions. In accordance with this idea, all the elements that can be found in nature also occur in **Schönbusch Park**. To provide relief to the relatively flat area, a lake and a canal were dug. The excavated earth was then used to create a small hill. After that a belt walk was added, which afforded views across the park and surrounding area. Other paths followed, which always had to follow a "natural" course and could never be completely straight, and numerous trees were planted, including many rare, exotic varieties. The goal was to imitate nature's diversity. Most of the buildings that grace the park were positioned to provide interesting views but were also harmoniously integrated into the landscape to form a picturesque vista themselves. This is the case with the **observation tower** and the **Red Bridge** (Rote Brücke). It applies also to such buildings as the **dining hall** (Speisesaal), the **Monopteros** or the **Nilkheim Pavilion**, which houses a billiard room.

Apart from these buildings there are two small settlements in the park, the **hamlet** with a few small farmhouses and the **Wacht** with two shepherds'

cottages and a barn. These reflect the longing for a simple, natural life, which was propagated at the time by the Swiss philosopher Jean-Jacques Rousseau.

Two other buildings are the **Philosopher's House** (Philosophenhaus) and the **Temple of Friendship** (Freundschaftstempel). Buildings of this sort in the park of an elector and prince-bishop should make one sit up and take note as something that in today's eyes may appear purely picturesque but at the time was viewed as showing allegiance to the dramatic intellectual reorientation in the second half of the eighteenth century. Whereas in the past a chapel indicated a religious view of the world, the Philosopher's House stands for the de-

The palace's Neoclassical banqueting hall by architect Emanuel Joseph Herigoyen was modelled on English examples.

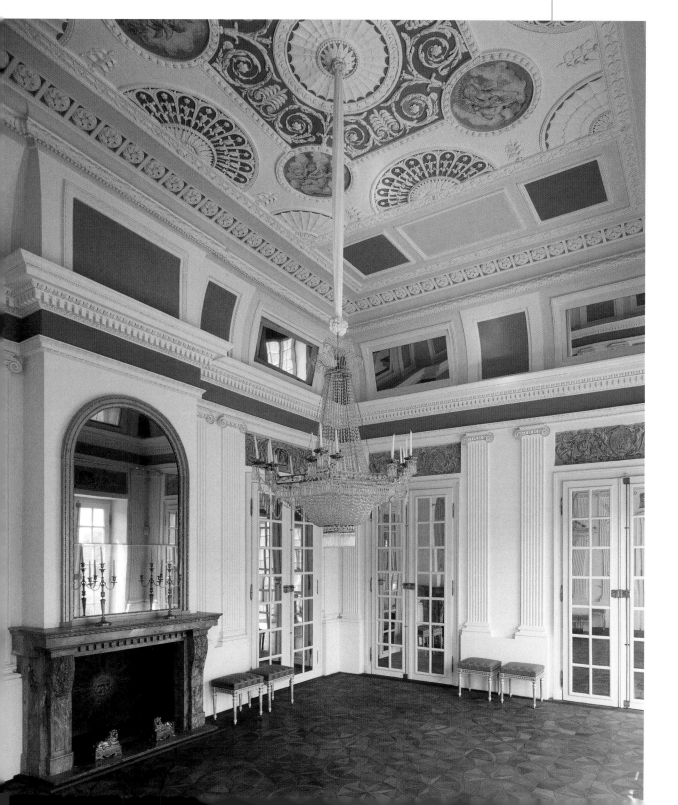

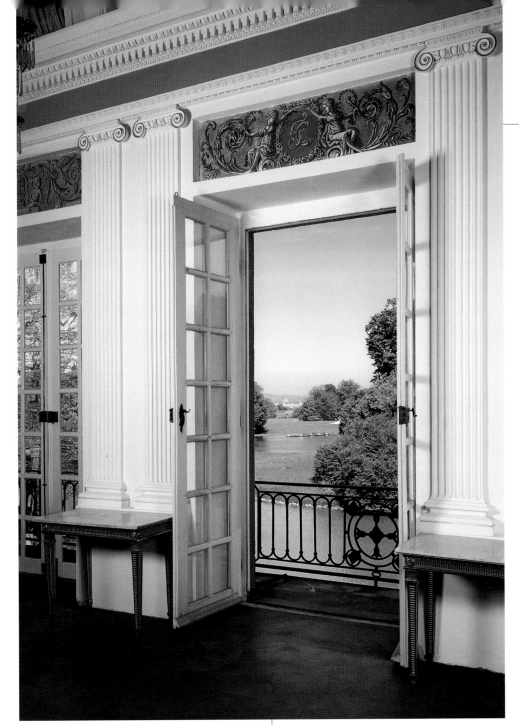

parture from an ecclesiastical and dogmatic explanation of the world in favour of an individual, philosophical perception. The Temple of Friendship also marks a change, in this case in the understanding of relationships. The ideal of friendship that overcame the barriers of social status, the emotional and subjective bonds between people, questioned the hierarchical social model, which was valid in absolutist society.

The fact that these intellectual ideas can be found in a prince-bishop's park demonstrates his enlight-ened attitude. One could almost believe that Schönbusch is not a palace garden but a park for the people. And to a certain extent this is true, for as early as 1783 the philanthropic prince-bishop passed a decree that permitted public access to almost the entire park. The palace could even be visited when the Prince was not resident.

The **palace**, which we will visit last of all, does not stand out for its size—akin more to a palais than a residence—but for its exquisite Neoclassical furnishings. It comprises just a dozen rooms. From the wide entrance hall a staircase leads up to the top floor. Besides two drawing rooms there is the prince-bishop's bedroom. The main room is the Great Hall, or Grosser Saal, with its restrained stucco decoration. The view from the window is like a framed landscape painting. Surrounded by trees one can identify Johannisburg Palace in the distance.

Front cover: Würzburg Residence, view of the middle section of the garden façade
Front flap: Giambattista Tiepolo, detail of the personification of America, from the staircase fresco in the Würzburg Residence
Back flap: Würzburg Residence, Cabinet of Mirrors (Spiegelkabinett)

Photographic credits: All pictures are from the archives held at the Bavarian Administration of State Castles, Palaces, Gardens and Lakes (including photographs by Alfen, Bertram, Custodis, Hetzenecker, Mayr, von der Mülbe, Schwenk/ v. Platen and Weiss), with the following exceptions: p. 1, p. 2 (top), p. 6 (bottom), p. 8 (top), p. 9 (bottom), p. 17 (top), p. 26, p. 27 (bottom), p. 28: A. J. Brandl, Munich; p. 7 (bottom): R. Nachbar, Reichenberg; p. 35 (bottom), p. 41: R. Schmid, Bildagentur Huber, Garmisch-Partenkirchen; p. 38: Bayerisches Landesamt für Denkmalpflege (E. Lantz), Munich

Cartography: Anneli Nau, Munich

© Prestel Verlag, Munich · London · New York, 2002

Die Deutsche Bibliothek – CIP Einheitsaufnahme and the Library of Congress Cataloguing-in-Publication data are available

Prestel Verlag, Mandlstrasse 26, 80802 Munich
Tel. +49 (0)89/38 17 09 - 0, fax +49 (0)89/38 17 09-35;
4 Bloomsbury Place, London WC1A 2QA
Tel. +44 (0)20/7323 5004, fax +44 (0)20/7636 8004;
175 Fifth Avenue, New York, NY 10010
Tel. +1 (212) 995-2720, fax +1 (212) 995-2733

www.prestel.com

Translated from the German by Rebecca Law, Vienna
Edited by Michele Schons
Designed and typeset by Norbert Dinkel, Munich
Lithography by ReproLine, Munich
Printed and bound by Sellier Druck GmbH, Freising

Printed in Germany on acid-free paper

ISBN 3-7913-2608-2 (English edition)
ISBN 3-7913-2556-6 (German edition)